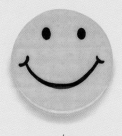

1

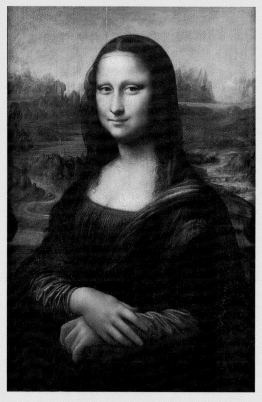

2

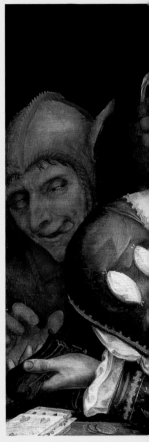

4

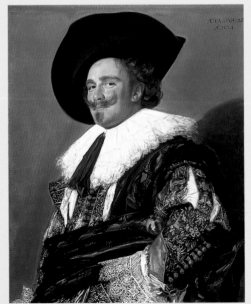

3

5

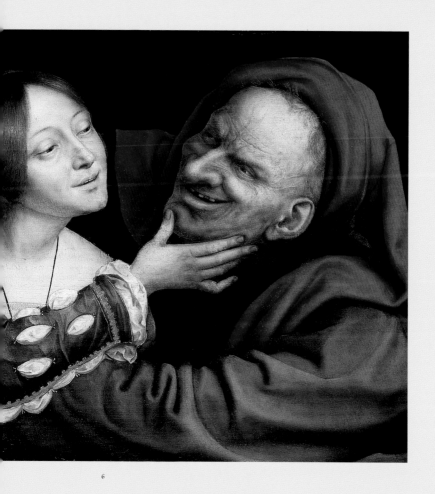

6

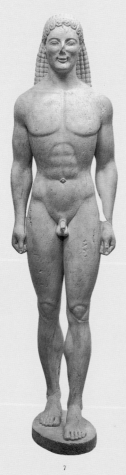

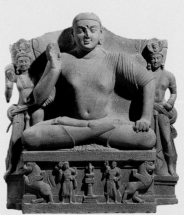

7

8

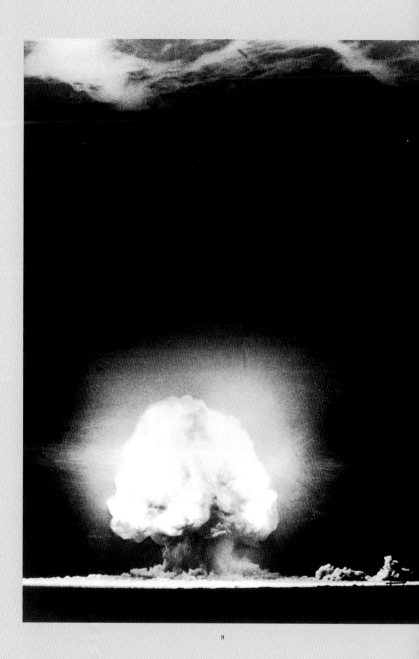

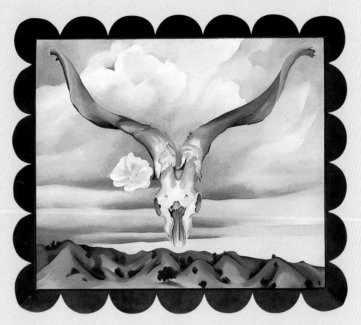

10

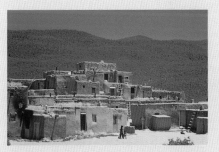

11

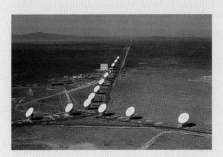

12

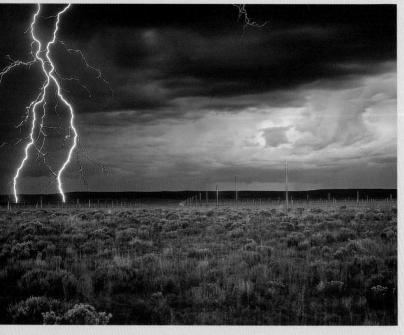

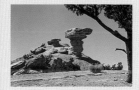

14

15

16

17

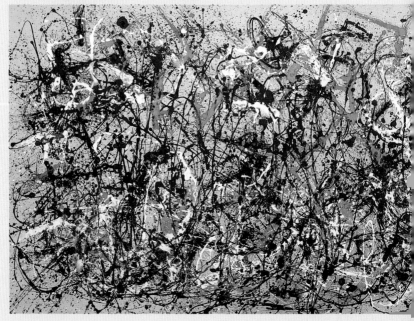

18

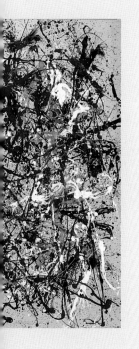

19

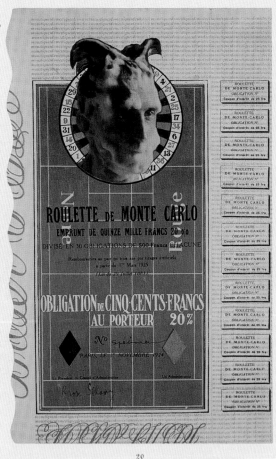

20

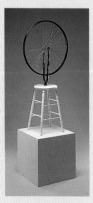

21

Deep Design

Art issues. Press
Los Angeles

Series Editor: Gary Kornblau

Art issues., a bimonthly journal of contemporary art criticism

The Invisible Dragon: Four Essays on Beauty, by Dave Hickey
Frank Jewett Mather Award for Distinction in Art Criticism in 1994

The World of Jeffrey Vallance: Collected Writings 1978-1994
Co-editor: David A. Greene; Introduction by Dave Hickey

Last Chance for Eden: Selected Art Criticism by Christopher Knight 1979-1994
Edited by MaLin Wilson; Introduction by Dave Hickey
Frank Jewett Mather Award for Distinction in Art Criticism in 1995

Mythomania: Fantasies, Fables, and Sheer Lies in Contemporary American Popular Art
by Bernard Welt, with "The Dark Side of Disneyland" by Donald Britton
Lambda Literary Award Finalist in 1996

Air Guitar: Essays on Art & Democracy, by Dave Hickey

To order or for more information contact:
Art issues. Press
8721 Santa Monica Boulevard, PMB #6
Los Angeles CA 90069
Telephone (323) 876-4508

Distributed Art Publishers (D.A.P.)
155 Avenue of the Americas
New York NY 10013
Telephone (800) 338-BOOK

Deep Design

Nine
Little Art Histories

LIBBY LUMPKIN

Art issues. Press
Los Angeles

cover INGRID CALAME
FWEP, 1995
(detail, mirror image)
Enamel on board
24 x 24 inches
Courtesy of the artist
Photo: Luciano Perna

Art issues. Press
The Foundation for Advanced Critical Studies, Inc.
8721 Santa Monica Boulevard, PMB #6
Los Angeles, California 90069

© 1999 The Foundation for Advanced Critical Studies, Inc.
Essays © 1999 Libby Lumpkin
First Edition

This publication has been made possible through the generous financial support
of Lannan Foundation, with additional funding provided by Bohen Foundation and
the Challenge Program of the California Arts Council.

Manufactured in the United States of America

Library of Congress Cataloguing-in-Publication Number: 99-71243
International Standard Book Number: 0-9637264-6-3

For Dave

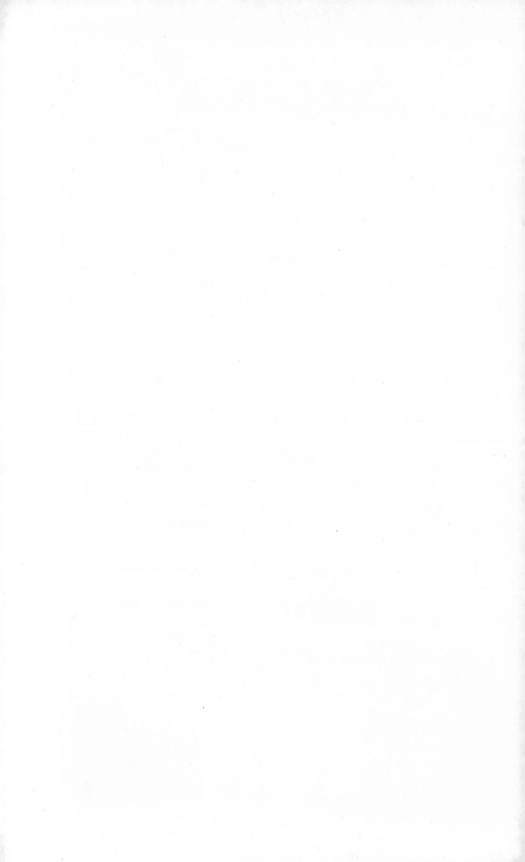

Contents

Devoted to Design

Most of the essays collected in this volume have been written out of compulsion, to come to terms with a few designs that have delighted, amazed, dismayed, or perplexed me. Each of these designs has decorated the immediate environment of my adolescent or adult life: the ubiquitous Smiley Face and Prohibition Symbol; the ambient inscription of New Mexico's "sublime" desert, in the midst of which I lived for ten years; the distinctly spectacular and contingent landscape of Las Vegas, where I now reside; and the uneven terrain of feminist art, which, for many years, has been my most visited intellectual domain.

In these essays, I have approached the art object as a puzzle, with no particular theoretical or methodological agenda in place, although a number of theoretical and methodological issues arose in the course of writing them. In each case, I have attempted to solve the riddle of how the individual design means what it means, and how it has maintained or lost efficacy in social discourse. How, for example, has the Prohibition Symbol, whose simple red circle with diagonal slash must be admired for visual economy, succeeded while so many equally economic symbols have failed to enter the vernacular? how has the little yellow Smiley Face, with its bland good humor, achieved such enormous popular currency in the face of disso-

nant social mood? or how have certain artificial landscapes entrenched themselves in the public imagination?

Having completed the first seven of these essays—which amount to little art histories of diagonals, smiles, showgirls, goddesses, chance art, feminist art, and landscapes of varying kinds—I began to understand, perhaps belatedly, the peculiarities of my method. I noticed a unifying thread in the form of the question consistently posed: "how?" This question seemed to place my method somewhat at odds with the prevailing tendency in art studies to ask of works of art the question "why?"

To ask how an object makes its meaning, of course, is not the same as asking why the object exists. "How?" is a small, practical question, tightly focused on the mechanics of form, that necessarily leads to a study of the history of responses to similar designs; "why?" is a broad philosophical inquisition that turns the eye from the object to the person or culture that produced it, necessarily resulting in teleological argument. "How?" denaturalizes prevailing aesthetics; "why?" leaves prevailing aesthetics in place. "How?" is a question of design; "why?" is a question of intent.

Consequently, and a little uneasily, I was forced to conclude that my method is formalist. Taking art to be an inescapably embodied practice, I had focused on design, which is the product of practice and the only historical component of a work of art. According to prevailing opinion, however, the formalist method is in every sense debased: counterintellectual, apolitical, irrelevant, or simply evil. I consoled myself with the realization,

now gathering consensus, that Clement Greenberg, the primary "formalist" target of academic theorists, is a target of straw—less a formalist than a transcendental materialist.
It appeared to me, in fact, that early twentieth-century theories of art, like the late twentieth-century theories that developed in kind, have blurred the distinction between artificial and organic types of design by viewing art objects collectively, as the constructed expressions of a generalized or essential "race," culture, human-ity, or collective poesis. These theories account for design through recourse to various concepts of evolutionary or historical progress, or psycho-analytic models of human behavior. In sum, they analyze works of art from the top down.

It then occurred to me that studying art from the bottom up—interpreting design as the artificial configuration or arrangement of visible materials in the presence of a beholder at particular points in time and space—might have political value in itself, might potentially, in a small way, even contribute to the greater good. At the very least, to dissent from the acad-emy in this way, I would be defending the com-mon labor of human individuals. So, on two occasions I have been inspired to write what amount to postscripts devoted not to individual designs, but to the theories or conventional ideas that have affected the presentation, study, and even the production of certain fine art objects in a perverse or negative way.

After reviewing the "Bad Girls" exhibition of 1994, it seemed clear to me that the feminist art movement had devolved into a kind of proprietary communitarianism that be-trays the feminist cause. Thus, I followed with the commentary "Virtue Be Damned!" an essay

devoted to pointing out the logical incon-
sistencies in the theories upon which many in
the movement have relied and which have con-
tributed to the deflection of feminism from
what I regard to be its proper goal: power for
women. In a subsequent review of the even
more disappointing "Sexual Politics" exhibi-
tion of 1996, I clarified my position that the
failure of both these major, landmark presenta-
tions of feminist art must be attributed in part
to the failure of their curators to hold women's
art accountable for efficacy of design, instead
assigning value according to virtuosity of artis-
tic intention as manifest in explicitly feminist
themes. (These essays are here revised as
"Feminist Art i, ii, and iii.")

Indeed, it quickly became apparent
that, rather than ushering in a new era of femi-
nist art, "Bad Girls" and "Sexual Politics"
effectively destroyed the genre of the feminist
art exhibition, ending the feminist art move-
ment not with a bang, but with a whimper. It
further appeared to me that the theoretical
biases that devastated the feminist art move-
ment had contributed to the crisis in art stud-
ies being addressed by theorists at that
moment, around 1996. In any case, the solutions
being proposed seemed less than sanguine to
me. Some art theorists argued over the type of
unconscious or somatic conditions out of
which art emerges, and others argued over
which philosophical discipline they would have
art studies most be like, but nearly all con-
curred on the need to create an "interdiscipli-
nary" discipline that, in effect, would replace
the study of art with the study of vision. At a
fundamental level, the human activity of look-
ing would replace the object at hand. 11

If some art theorists feel compelled to displace the object of their discipline and change the name of it to visual studies, I do not. Nor do I see the need of subscribing to the oxymoronic idea of an interdisciplinary discipline, which only serves to denigrate the innocent idea of specialization and to theatricalize what appears to be a widespread puritan distaste for material works of art. Although grand, abstract questions certainly are worth asking (contributing, as they have, to various imaginative and sometimes compelling constructions of visuality), overarching systems have always collapsed when confronted with paradigmatic change, and even when confronted with sameness, they prove unforgiving. Naturalized constructions of practice and design blur the distinction between the objects and the persons or cultures that produce them, leaving little hope of redemption, the implication being that unless human imperfections of character, unconscious, gender, or culture are atoned, human designs remain inadequate.

Philosophy is not the home of joy, nor is it the residence of artistic triumph, and for these reasons it is not my chosen field. I have always preferred to follow a course that allows me to admire as well as criticize, to seek out difference as well as sameness, and to use history instead of speculation as my tool. I feel that the study of the complexities of design is as worthy as the study of the mysteries of human existence, and it has been distressing to see the heart of the discipline of art studies disappear, leaving a gaping lacuna where design should be. Thus, I was moved to write the final essay in this book (here revised as "The Redemption of Practice"), which points out

the dire consequences of regarding art as an exclusively philosophical endeavor—forgetting that art is first and foremost a practice. Based on the premise that the virtues of practice are distinct from the virtues of intentions, this essay may be taken as a sign of my commitment to a formalist method grounded in the history of social response and as something of an afterword to the sum of my work. If, then, in my own practice I advocate a theory—as every course of action must—it certainly is not a theory of art, but, at most, a theory of study.

In any case, the abstract component of any discipline is efficacious only insofar as the speculative readings it generates are based on observable, concrete events. And in truth, there is no shortage of acute observers today. Brilliant observations are made even by some who labor under duress of their own top-heavy theories. Thus, as the discipline of art studies ascends to interdisciplinary heights, I have to imagine that a place will remain for a critic beguiled by earth-bound human invention. As diverse as the essays in this volume may seem, each of them is dedicated to those who remain delighted, amazed, dismayed, or perplexed in the company of art, to artists who suffer the frustrations and savor the triumphs of practice, and to those such as myself, who are simply unabashed and unwavering in their devotion to design.

The goal of society is human happiness.

●

DECLARATION

OF THE RIGHTS

OF MAN

The Smiley Face

In 1967, University Federal Savings & Loan of Seattle had a problem. Its neighborhood had become home to the counterculture's malcontents, whose loitering, incendiary violence, and political theater had distressed the local populace, destroyed bank property, and generally interfered with the selling of accounts. Bank officials had the solution: They would make everyone "happy" again. To this end, they hired local ad man David Stern to come up with a campaign. Stern's slogan, spun off from a song in the hit musical *Bye Bye, Birdie*, didn't exactly sing. "Open a savings account, and put on a happy face." But his logo, a little yellow button with simple black lines, hit a major chord. The Smiley Face was born.

Perhaps it is less than coincidental that the Smiley Face emerges in the wake of the surge of popular interest in the psychology of nonverbal communication that had developed in the nineteen sixties, thanks largely to the publication of Erving Goffman's best-selling books on the science of social interaction. The logic of Stern's campaign relied upon the idea that seeing smiles produces smiles and also in part on the theory first proposed in different forms by Charles Darwin and William James in the late nineteenth century, which has come to be known as "emotion feedback": The act of smiling in itself generates a real feeling of happiness in the one who smiles. This logic, however, cannot entirely account for the Smiley Face's phenomenal proliferation, nor for its spread from capitalist

trinkets to hand-painted versions on deadhead Volkswagen vans to bumper-stickers on Protestant fundamentalist sedans. The mania finally subsided a bit in the early nineteen eighties only to surge again at the end of the decade, becoming the insignia of the Czechoslovakian opposition movement Civic Forum, showing up on the T-shirts and jackets of London's Acid House Club scene, and decorating one of Bloomingdale's top-selling lines of haute couture.

Obviously, the little yellow face has been able to move with ease through many widely disconnected late twentieth-century cultural sites. The simple pictographic design, which abolishes the slightest insinuation of interior motive and presents the smile in linguistic innocence as a free-floating sign, apparently is flexible enough to signify for the benign intentions of any commercial, social, or political enterprise to which it is affixed. Its persistence and ubiquity suggest that the idea of secular happiness has been thoroughly naturalized. Yet in the long history of Western culture, secular happiness has not always been so at home, and smiles in art often have been met with decidedly more anxious response.

*

Perhaps nowhere is smile anxiety more clearly expressed than in the romantic mania that long enveloped Leonardo da Vinci's *Mona Lisa*. By the end of the nineteenth century, it had reached such intensity that an exasperated Paul Valéry felt compelled to respond: "I do not think I can give a more amusing example of common attitudes toward painting than the celebrity of the Gioconda smile, to which the adjective *mysterious* seems to be irrevocably attached. This wrinkle in a countenance has been fated to give rise to the kind of writing about art that is supposedly justified, in all literatures, by such a title

16

as 'impressions.' It has been buried under piles of words and rendered invisible by paragraphs that begin by calling it 'troubling' and wind up with a generally vague description of a soul." The mania continued deep into the twentieth century and has never entirely gone away. Along with the "impressionistic" theorizing of the kind Valéry deplored, there has been no shortage of serious scholarship devoted to the meaning of the *Mona Lisa* smile.

With the celebrations of the 500th anniversary of Leonardo's birth that took place in 1952, and the u.s. tour of the *Mona Lisa* that followed in 1963, the scholarly debate reached a crescendo—but no conclusion. The lack of consensus should not surprise. The troubling nature of the Gioconda smile seems to have been the subject of discussion almost from the moment of its creation around 1503. The earliest written commentary, penned some fifty years later by Giorgio Vasari, must have drawn on a discourse already in circulation. Although Vasari never saw the painting himself, he speculated on its meaning, marveling at its naturalism and recounting the devices Leonardo employed to maintain that smile on the countenance of his sitter: music, song, and jest.

In his essay on the *Mona Lisa*, Valéry had gone on to argue that Leonardo did not make use of imprecise observations or random signs. Although we may be inclined to agree, it is Leonardo's skill at design that should be acknowledged. Unlike any smile to come before it, the *Mona Lisa*'s enlists the complicity of the beholder and thus has been a sort of Rorschach image onto which succeeding generations have projected their fantasies—about the woman depicted, the psyche of the artist, and the meanings a smile can hold. The mystery that makes *Mona Lisa*'s the most controversial smile in Western

17

culture, however, surrounds any smile set free from narrative or identifying iconography and projected toward the beholder. Today, such smiles are naturalized in Western culture. Thus, the scholarly obsession with fixing its meaning suggests an anxiety resulting from pervasive distrust of the rhetorical aspects of smiles themselves.

The character of this distrust is made explicit in the literally hundreds of scientific studies devoted to the facial expression of emotion. According to the many psychologists, psychobiologists, and behaviorists who study expression, the smile represents a reactive emotional state: An outside stimulus affects one and makes one happy, thereby generating a spontaneous facial expression. This assumption underlies the experiments performed in order to verify the Darwinian proposition that human facial expressions have universal efficacy. In these studies, the typical method of investigation is to test subjects using photographs or drawings of faces expressing emotions. Happiness, sadness, fear, surprise, and anger are the types most commonly tested, subjects being asked to assign particular emotions to properly corresponding images. (With some cultural and gender variations, Charles Darwin's hypothesis so far has been confirmed.) Interestingly, of the five main facial expressions that are tested, *only* the smile is studied in its variations.

According to most scientists, the smile can be mixed into an emotion other than happiness—embarrassment, for example—but in general there are only two significant categories: the "true" smile and the "false" smile. Although the thought of such experiments being conducted under the auspices of our nation's universities may be smile-inducing in itself, behaviorists have gone to great lengths to distinguish

18

true smiles from false ones by examining hidden physical indicators. Electrodes attached to facial muscles reveal that the true smile involves the *orbicularis oculi* muscles around the eyes, while the false smile employs only the *zygomaticus majors*, at the corners of the mouth. (For those of you on the lookout, the true smile takes less than four seconds, longer-lasting smiles are likely to be false.) Since no practical application for smile detectors has been developed that would help us make our way through the world of duplicitous smiling, the results of these so-called scientific studies are virtually useless. A study of the premises upon which these investigations are based, however, may be of some value.

The assumption that universal spontaneous reactions constitute the true smile, with its corollary premise that other kinds of expression are simple lies, assigns virtue only to the organic model of nonverbal communication. It ignores the social history of manners and the semiotics of images, and, in general, puts a negative spin on any systematic investigation of the *rhetorical* aspects of expression. Implicit in all scientific theories of expression is the idea that a smile indicates happiness; the true smile signifies *true* happiness, the false smile the pretense to happiness. Concern for *gravitas*, however, is never at issue: No "true" frown? No "false" frown? Nor is any consideration given to the possibility that happiness might not bear universal meaning in the first place.

<div align="center">✳</div>

Understandably, no researcher of smile expressions has yet attempted to test subjects using pictures of archaic Greek art. The slightly pursed and upturned lips that recur across the spectrum in sixth-century Greek art—on the faces of kouroi, korai, gods, centaurs, warriors, and monsters—have

19

perplexed modern classicists for years. Plagued by a scarcity of archaeological and literary evidence, scholars have attributed the archaic smile variously to the Greek concept of *agalma* (a thing of pleasing delight), a centaur-related leer, technical accident, and, most recently, to the sly acknowledgment of homoeroticism. Superseding these variant attributions is widespread agreement that the smiling faces are indicative of the naïve optimism purportedly present in the fervent moments preceding the birth of rationality and moral ethics—signs of a new animate existence, a burgeoning individualism bursting through the restraints of abstraction to find truer expression in the naturalism of Classical form. The operative analogy, of course, is the carefree and happy childhood preceding the conscious introspection and *gravitas* of maturity.

Even so, classicists admit that no theory successfully accounts for all manifestations of the archaic smile. What works for the kouros doesn't for the kore, and makes even less sense when applied to a dying warrior or ravaging centaur, and less sense still when applied across the span of the century. The finer points of historical argument are not the object of this essay, but it would seem that the uncertainty of archaic Greek life, lived in the shadow of arbitrary, powerful, and vindictive gods who were thought to begrudge humans their happiness, argues against the probability of a *perky* sacred art—and suggests that the problematic interpretations of the archaic smile may be the result, at least in part, of the tendency to project modern concepts of psychological happiness onto a culture whose sense of "happiness," and even of "the personal," are profoundly foreign to our own. In all likelihood, the mysterious smiles were not perceived as signs of happiness, but signified mystery itself—the expression of a transcendent knowl-

edge possessed only by the divine.

At least *transcendent secret knowledge* is a reasonable interpretation of this same type of smile when it returns to systematic use in the Near East in the first century C.E. In the Hindu and Buddhist religions, whose early practitioners placed great importance on sign and gesture in the anthropomorphized versions of deities, spiritual fulfillment is not contingent on moral principles. It is unlikely, then, that the beatific expression on the faces of Hindu or Buddhist icons have much to do with human emotion: Buddha is not happy, Buddha has attained Nirvana. His smile signifies the privileged knowledge of one who has achieved ultimate reality. Still, there is more than one kind of secret knowledge, and a smile encountered outside narrative context can speak as easily of erotic courtship behavior as of enlightened transcendence, as in Shiva and goddess figures, which retain elements of ancient fertility traditions even as they embody the transcendent discipline of the ascetic. Their smiles preserve the secretive aspects of divinity, but with potent ambiguity.

In the West, from the Classical era until the Renaissance, the smile rarely possesses this kind of ambiguity. In fact, throughout the period smiles tend to be carefully segregated into secular or religious contexts, and any confusion that might be generated by encounters with smiling icons is avoided through abstinence; smiles tend to be confined to narrative scenarios in which the complicity of the beholder is not required. The Madonna smiles not at the viewer, but at the infant Jesus; Gabriel smiles with the secret of his happy news, but only in the setting of the annunciation; a chorus of angels smile, but only in the presence of God. Occasionally, the beatific expression is found in secular contexts—tender ex-

changes between family members turn up now and then in Greek and Renaissance art—but the vast majority of secular smiles occur in erotic scenarios. The Hellenistic nymph smiles in the presence of the satyr, whose wide, animated grin of Dionysian abandon (a smile with full *orbicularis oculi* involvement) is later used to indicate debauchery in the morality lessons of Northern European Renaissance painting. So, although the Western smile may signal the transcendence of the beatific or the pleasure of the erotic, it does so only at the safe distance narrative provides.

Thus, when Leonardo turned the Gioconda smile toward the beholder and liberated it from narrative enclosure, he breached the West's longstanding, if unwritten, prohibition against ambiguous facial expression. By introducing that wrinkle into the social and theatrical structure of the portrait, Leonardo secularized and privatized the rhetorical power of the icon, and created one of the most transgressive and disturbing images in the history of art. Was this Leonardo's purpose? Historians can't say, although the ambivalent expression on the face of his subsequent *St. John the Baptist* suggests that he fully grasped the implications of what he had done. Leonardo had proved that when the secret part of secret knowledge is left unexplained, the smile generates an anxious response in the beholder. His *Mona Lisa* continues to prove that a smile, on its own, is anything but universal. Where Vasari finds a sweet expression "rather divine than human," his own sixteenth-century contemporaries (mostly the French ones) discover the erotics of the courtesan; where Sigmund Freud uncovers the sublimation of unconscious desire, Marcel Duchamp reveals androgyny and André Malraux envisions the "eternal feminine." If today's psychologists were to analyze the

Mona Lisa's smile using the Darwinian model, they no doubt would discover a simple case of false happiness.

<p style="text-align:center">*</p>

Darwin was not the first to systematize the study of facial expression, nor to deny the rhetorical aspects of smiles. In the second half of the seventeenth century, Charles Le Brun codified the emotions into a schematic lexicon intended to aid legibility in painting. Although it is difficult to think of Le Brun's highly mannered academic paintings in terms of the *denial* of rhetoric, his system of allegorizing facial expression was premised in the Cartesian notion that the "passions" are names for certain physical actions that take place in the body, a notion that differs only in refinement from current neuro-physiological theories of the emotions.

The implicit hierarchical order in which Le Brun categorized expressions, however, is almost a perfect inversion of that of today's science. Unlike our academicians, who prioritize the smile, Le Brun devoted equal attention to expressions such as admiration and veneration, and even more to the complexities of negative states of mind such as fright, sadness, and bodily pain, which fit in more readily with the *gravitas* of seventeenth-century history painting. He did, however, distinguish three separate motivations for the passions that result in the beatific expression: *ecstasy*, caused by an object "above the knowledge of the soul"; *love*, an expression that results only when this passion is "pure"; and *joy*, caused when "love inspires the soul." For what he called laughter, an animated grin that closely resembles today's true smile, Le Brun offered no explanation, nor expressed any concern over veracity. For Le Brun, the beatific smile was the true smile, and laughter of no special interest—in contrast to twentieth-century scientists, for

whom the animated grin is the only true expression and the beatific smile (limited to *zygomaticus majors* only) is a lie. Since this inversion in the hierarchy of smiles cannot be accounted for by refinements in the so-called science of expression, it surely could only derive from a change in the perception of *happiness*.

Though the archaic Greeks conceptualized neither personal nor religious happiness, following Plato, eudaemonia remains an important aspect of ethical thought into the twentieth century. And though the vicissitudes of happiness in Platonic idealism, Aristotelian communal well-being, Stoic internal tranquillity, Neo-Platonic unity, and Christian blessedness are extreme, the most radical transformation occurred in the years between St. Thomas Aquinas, who advocated the notion that perfect bliss was obtainable only through beatific knowledge of God, and Thomas Jefferson, for whom material happiness was the touchstone of political sovereignty and a legitimate secular pursuit. Until the revolutions in America and France legitimized the recently developed and increasingly popular idea that happiness is a social virtue, the morality of happiness was always at issue. Should it be obtained in this world or the next? Should it be identified with pleasure or virtue? Thus for Le Brun, the animated grin could have no priority in history painting, having long since been encoded as a signifier for the debauchery that ensues from ahistorical, natural desire. And until the Utilitarian concept of hedonistic happiness, or secular pleasure, was raised to the pinnacle of ethical theory at the end of the eighteenth century, the secular smile remained something of an impertinence.

✳

If Le Brun's urge to codify natural expression suggests anxiety at the prospect of an increasingly secular and individ-

ualized ideal of happiness (an anxiety first manifest in six-teenth-century responses to the *Mona Lisa*), then the genre paintings of seventeenth-century Holland, with their endless procession of smiling faces, would seem to celebrate that very ideal. The Dutch, however, felt the pressure too. They may have been *secretly* celebrating material happiness with raucous abandon, but they consistently confined the animated grin to narratives of debauchery, or to images of those in the peasant class who were cast as embodiments of these narratives. Hence the singular peculiarity of painter Frans Hals: In a gesture as transgressive and as quirky as Leonardo's, Hals crossed class boundaries. He removed the grin, or animated smile, from the morality tale and placed it where it had never been seen before. Early in his career, in just a few paintings, he presented the ani-mate smile—the twentieth-century's true smile—in a portrait.

It is often noted that Hals's *Laughing Cavalier* of 1624 does not actually appear to laugh. The discrepancy in the *zygo-matic* area of this particular example of Hals's smiling portraits aside, not even our smile-scientists would question the gen-uineness of the cavalier's expression. (Although they might want to attach electrodes to his hips and wrist to test it.) In any event, for most of its history the *Laughing Cavalier* has emblematized the prosaic realism and technical mastery required to capture the natural spontaneity of ebullience; the expressive impulse that the reactionary Le Brun later sought to encode as allegory, Hals embodied in gestural strokes of paint. If Hals's smiling portraits seem not to possess the same sense of mystery as Leonardo's *Mona Lisa*, it is only because smiling portraits are so familiar to us. The animated grins that prolif-erate in the American cultural vernacular defuse the shock of its novelty. Thus, as simply jolly as the cavalier may seem, he

speaks of a different moral order. For even though the informality of Hals's smiling portraits has been recognized as ironic dissent from the conventions of courtly performance, that transgression is certainly only a metaphor for the larger transgression of earthly well-being. Hals's cavalier suffers not only "the embarrassment of riches," as art historian Simon Schama has argued, but also the embarrassment of joy.

No irony is required in the twentieth century for the multitude of grins that proliferate in portraiture, advertisements, and throughout the political landscape. Even before World War II, the happiness that for Jefferson was a political promise had become the material demand of the citizens of industrialized nations, self-denial existing only as a reflex to scarcity of goods. Even debauchery, which moral thinkers from Immanuel Kant to Freud viewed as an impediment to civilization, was elevated to respectability when Ferdinand Marcuse revised Freud's pleasure principle to make all forms of sexual satisfaction a legitimate goal. This intensified pursuit of happiness reached a crisis point in the nineteen sixties, when the cultural revolution in the United States, the student revolution in France, and the political revolution in Czechoslovakia each suggested that Utilitarianism as a social ideal had failed.

While these revolts hardly precipitated a wholesale return to spirituality or puritan ethics, they did coincide with a manifest escalation in a general distrust of rhetoric. French academics literalized language; Minimalists literalized art; and hippies, with the aid of chemical stimulants, literalized bliss. Nonverbal communication and social interaction became science, and the veracity of the smile became the obsession of psychologists. Scholars fixed the meaning of the *Mona Lisa* (as best they could), and Andy Warhol separated the fetish from the

26

face. Finally, the beatific smile returned in its most archaic form: the Smiley Face.

This little icon, of course, is no more indicative of pervasive happiness in American culture than the archaic smile confirms the existence of a happy ancient Greece. Although the Smiley Face's smile is beatific, it has no secret knowledge, no hint of the erotic, and no promise of ultimate bliss. "Have a nice day," after all, is not the same as "have a sublime life." The Smiley Face is just a free-floating signifier that works as well in Sunday schools as it does in commercial stores—a dematerialized material grin. And even though today's academic philosophers continue to perfect the discipline of eudaemonics, happiness seems to be permanently relegated to the field of psychology, where the veracity of this emblem of social success may be scientifically determined. With no ulterior or interior motive, however, the Smiley Face continues to proliferate as it mindlessly denies the failure of social revolutions, the rhetoric of the smile, and the secret of happiness.

*The new archivist . . . will
ignore both the hierarchy*

of VERTICAL *propositions
which are stacked on top of
one another and the*

HORIZONTAL *relationship established between phrases, in which
each seems to respond to one another.*

*Instead he will remain mobile,
skimming along in a*

kind of DIAGONAL *line that
allows him to read what could
not be apprehended
before, namely statements.*

Is this perhaps atonal logic?

●

GILLES DELEUZE

The Prohibition Symbol

It was not so very long ago that the symbol most commonly found over the doorways and on the walls of Western culture's public spaces was the Holy Cross. Today's most common symbol is similar in its Euclidean simplicity but has a profoundly different design—the Prohibition Symbol. In the nineteen eighties, the red circle with diagonal slash, also called the no sign, broke out of its confinement in the domain of traffic signage, where it had languished inauspiciously since its creation in the late nineteen twenties, and entered popular vernacular. Although you couldn't say the Prohibition Symbol is a particularly popular symbol—in the sense that, for instance, the Smiley Face enjoys broad popularity—its efficacy cannot be denied. The meaning of the no sign is clear; it says "do not," and, on a daily basis, for the sake of safety or social order, it proves its effectiveness at prohibiting the quotidian conveniences, pleasures, or vices in which average citizens might wish to indulge. Indeed, it has become one of the most widely accepted, easily understood, and ubiquitous abstract symbols in the Western world, and beyond.

The efficacy of the Prohibition Symbol, I would suggest, derives precisely from the diagonal element of its design, and from the applicability of that design to the disciplinary agendas that pervade recent times. It functions as a word. For example, the cautionary message that is conveyed by the conflation of image and angle in Rogier van der Weyden's *Lamen-*

tation of Christ in the *Miraflores Altarpiece* of 1440-44 or in Peter Paul Rubens's *The Elevation of the Cross* of 1610-11—the "Do not crucify God" message embodied in the diagonal alignment of Christ's body—is divided in the no sign, the "do not" diagonal separated out and superimposed on the prohibited act. Thus, the no sign anticipates the language-based social and aesthetic strategies that rose to dominance in the nineteen eighties: interdiction. As such, it emblematizes those disciplinary agendas designed to normalize social relations: the "Just Say No" anti-drug campaign, the promotion of "family values," and the ongoing feminist, multiculturalist, and fundamentalist endeavors to regulate images and words.

<p style="text-align:center">✳</p>

Given the present ubiquity of the no sign, it is remarkable that the u.s. Department of Transportation resisted its importation from Europe for forty years, from 1931, when the symbol was first included in a League of Nations proposal to establish international road signage, to 1971, when finally it was ratified by the United States in the last of a long series of proposed United Nations agreements. Debate over the United States's use of the symbol began in the late nineteen sixties and revolved, in part, around the broader question of whether to institute signage based on the permissive message—telling drivers what they *may* do as opposed to telling drivers what they may not. (The permissive message had some currency in Canada, whereas the prohibitive message prevailed in Europe.) The prohibitive message, it was argued, is overly complex, for two pieces of information must be conveyed: a description of the offending action, and the signal that prohibits this action. Adding to the complexity, the arbitrary meanings assigned to abstract signage, as opposed to the accepted meanings of words

30

or explicit meanings of pictographs, was felt to place too heavy a demand on the public, who must learn and remember the intended message. The remainder of the debate focused on the design of the Prohibition Symbol itself, which was found wanting in one crucial aspect, summed up neatly in the title of a study devoted to the subject: "The Slash Obscures the Symbol on Prohibitive Traffic Signs."

Despite all the deep-seated reservations, the Department of Transportation finally capitulated, but only under pressure from high-profile advocates like Margaret Mead and R. Buckminster Fuller, who were calling for the establishment of a transcultural symbolic language. It also insisted that the United States Safety Standards Act be amended such that European signs would not replace American-style signs, consisting of words on shaped supports, but merely add to them. In fact, for many years the Prohibition Symbol remained confined to low-speed zones, such as parking zones, and to the domain of foot traffic—sidewalks, terminal stations, government buildings—where its use is arbitrary rather than benign: In high-speed venues, it promotes safety; in parking lots and buildings, it denies privileges. No doubt its confinement to such venues, where its often annoying interdictions register emphatically in human consciousness, contributed to its apotheosis in the popular vernacular. The success of the no sign, however, would seem to rest primarily on the signifying properties of its design element. American traffic engineers might have capitulated sooner had they taken note of the diagonal's uses in the long history of Western culture. In fact, at the same time the traffic-sign debate was at its height, accounts of the art group De Stijl's "diagonal dispute" were being published in English for the first time.

31

The De Stijl dispute had erupted in 1924 when Theo Van Doesburg defected from Piet Mondrian's Theosophy-inspired Neo-Plastic doctrine of design and began organizing his geometrical abstract compositions along diagonal lines. For Van Doesburg, the diagonal was the central component of Elementarism, his own imaginative doctrine inspired by and modeled on a conglomerate of sometimes scientific, other times popular conceptualizations of Non-Euclidean and *n*-dimensional geometries, relativity theory, and theories of the fourth dimension. What disturbed Mondrian and caused him to resign from De Stijl and from his long friendship with Van Doesburg, however, was not the fanciful nature of Van Doesburg's conjectures, but the treason that the diagonal committed against his deeply held belief that horizontals and verticals constituted the proper foundation of art. Van Doesburg's *Contra-Compositions* were a slap in the face to Mondrian's conceptualization of opposing natural forces embodied in the horizontal and vertical lines that, when brought to intersection, create the harmonic perfection of a transcendent reality that lies behind all visual phenomena and that, when beheld, ameliorates the human spirit. Thus, Van Doesburg's diagonal not only violated Mondrian's perpendicular construction of visual morality, it also subverted his aspiration to redeem modern culture by using the visual environment to infect culture with virtue.

This was not the first time the diagonal had disrupted an otherwise classically balanced metaphysical construction. In fact, the Mondrian-Van Doesburg dispute recasts a similarly melodramatic controversy that erupted some 2,000 years earlier in pre-Euclidean Greece. Indeed, the *Grundlagenkrisis der griechischen Mathematik*, or foundational crisis of Greek math-

32

ematics, was initiated by the unwelcome discovery of the "irrationality" inherent in a diagonal line. The impact of this discovery had a devastating impact on the Pythagorean cult, whose followers placed their faith in a naturally mathematical cosmos constructed according to an abstract order that mystically dwells in whole numbers. In recent years, scholars have questioned much of the lore surrounding the discovery of the irrational number. Most doubt that the Pythagoreans kept their discovery secret, and that Hippasus was drowned at sea as divine punishment for revealing it. Some suggest no controversy occurred, and no one can say for sure whether it was Pythagoras himself, or one of his fifth-century disciples, who first came to terms with a geometrical magnitude not expressible as either a whole number or a fraction, as well as with the consequences of that discovery: the inference that logic and intuition might disagree.

One part of the story that almost all scholars accept, however, is that the discovery of the irrational number was made in the spatial domain of geometry, not in music or arithmetic. Although there is some dispute over which geometrical figure first revealed the irrational number, ancient sources report that it happened during the attempt to apply the Pythagorean theorem to a square whose sides each have the magnitude of 1, referred to in mathematics as the "one-sided square." A diagonal that joins any two corners of this square is equal to a quantity that we call the square root of 2, expressed as $\sqrt{2}$, and factored as 1.414214... (nonrepeating ad infinitum).

Whether this discovery created an ancient *Grundlagen-krisis* or no, this irrational number is in profound conflict with the Pythagorean doctrine of a divinely ordered universe manifest in whole numbers and resting firmly upon their primacy and truth. Fractions were acceptable in this cosmology only because they did not represent *parts* of a number, but ratios between whole numbers. The incommensurable relationship between the side and the diagonal of the one-sided square can be expressed as neither a whole number nor a ratio; it devolves into an infinite series.

*

Subsequent to the Pythagorean crisis, the diagonal would not be an explicitly articulated doctrinal problem again until the late nineteenth century. The whole numbers the Pythagoreans revered as mystical objects were transformed by Plato into abstract principles representing the ideal harmonic order of the universe, then were revived by third-century C.E. Neo-Platonists as constituents of their metaphysical hierarchies. In the fourth through the sixth centuries, the Neo-Platonic concept of vertical hierarchy was replaced with St. Augustine's perpendicular construction of the order of things, which was constituted by the horizontal unity of history and the vertical unity of the Scale of Nature, and which, in the Middle Ages, was transformed into various complex and imaginative Christian hierarchies that were often allegorized in art of the period. Consequently, the perpendicularity of Christian hierarchies, in combination with the powerful image of the Holy Cross, institutionalized the iconographic priority of the perpendicular composition and implicitly associated the oblique with sin, human fallibility, and secular historicity. Throughout the Middle Ages, images of the Holy Face, Christ

34

in Glory, the Virgin, and other transcendent Christian icons conform to the perpendicular, while images of Adam, the Prodigal Son, the erotic woman, Christ in Deposition or entombment, and other representations of human fallibility regularly fall on the diagonal.

The horizontal and vertical composition would continue to signify transcendent virtue well into the twentieth century, despite the religious, social, and scientific revolutions that gradually undermined, and finally made ridiculous, the concept of divinely sanctioned hierarchies. Thus, the diagonal organization of a work like Pieter Breughel the Elder's *Peasants' Wedding* of around 1568 may reflect Reformation indifference to dogmatic compositions, but it also embodies the painting's impious subject matter—the historicized enactment of ritual and the vulgarity of earthly celebration.

Moreover, if we take Leonardo's *Last Supper* of 1495-97 as the paradigmatic perpendicular composition, then Tintoretto's diagonally composed *Last Supper* of 1592-94 suggests the subtlety with which painting in the late sixteenth century reflects the ideological stresses of the Counter-Reformation— since Tintoretto's painting is less an iconic embodiment of Christian dogma than the embodiment of a subjective interpretation of religious experience and an evocation of the historical event itself. Thus, both Tintoretto and Breughel implicitly acknowledge the moral authority of the horizontal and vertical paradigm by placing their earth-bound stories in the real time and space that is signaled by diagonally organized compositions. At the same time, the mechanical frontal tilt of the figure of the erotic woman in illustrations from the Middle Ages is simply naturalized in the Renaissance, as in Titian's *Venus of Urbino* of 1538, and in a thousand Romantic paintings,

35

but never so overtly as in Francisco de Goya's *Maja*s of 1800-03. As late as the nineteenth century, in fact, Édouard Manet seems to demonstrate a continuing awareness of these conventions in his *Olympia* of 1863, whose form is borrowed as much from pious Neo-Platonist Sandro Botticelli's *Venus and Mars* of around 1475, as from Titian's *Venus of Urbino*, and whose near-perpendicular composition accentuates his model's affront to bourgeois sensibility by mocking a traditional sign of virtue.

The coded information embodied in the diagonal persists in the tangential, secular domain as well. In the diagonal stripe that in heraldry signifies bastardy and is called a "bend sinister," in the anti-Liberal despair of Théodore Géricault's *Raft of the "Medusa"* of 1819 and Eugène Delacroix's *Death of Sardanapalus* of 1828, in the Nietzsche-inspired autumn shadows that traverse Giorgio de Chirico's classical cityscapes, and in the tilted camera angles of horror and noir films, the diagonal composition signals an ominous threat to the implicit ideal of rational order. Despite the fact that on occasions the diagonal form has been employed to signify the positive attributes of power, progress, or "modernity"—one thinks of the slanted spears of Mycenean warriors headed into battle or the "dynamic" designs of certain twentieth-century Cubists, Futurists, and Constructivists, particularly Vladimir Tatlin's utopian architectural projects—such designs themselves contain an element of transgression: against an adversary, against the idea of a stable past or future, or against the idea of a universe governed by God rather than humankind. It shouldn't surprise that, outside a few brief moments in revolutionary Russia, the diagonal design would find its only positive institutionalization in the worldy and corrupt courts of Baroque Europe. Edward Ruscha's *Standard Station*s of the

nineteen sixties, with their classically diagonal construction, stand apart in their uncorrupted secular embrace of quotidian irrational order.

<center>✳</center>

The Prohibition Symbol takes full advantage of the venerable history of the diagonal's iconography. Its domestic domain, however, is benign and banal in comparison to the grandly tragic or blindly utopian sites visited by the diagonal in the past. It perfunctorily polices politesse and political agenda—"do not enter, smoke, park, litter, do drugs, get an abortion, be anti-gay." It represents the rule of law, not the word of God or the order of nature; it's a command, not a commandment. As such, it accommodates the obsolescence of a social morality grounded in absolute value, as delineated in the hierarchies of Christian religion and the rhetoric of Modernism, and perfectly emblematizes the currency of a cultural ethic based on relational values, as articulated in philosophies grounded in linguistics and difference. The no sign functions as a word, not a pictograph; the circle with slash is not a simplified picture of a thing, but a linguistically coded abstraction. The precise circumstances of its making are not known, though its diagonal element, which most often travels from sinister chief to dexter base, suggests it originally may have been conceived as a conflation of the two letters that constitute the word no.

In any case, the ubiquity of the red circle with slash suggests it may be one of the few, if not the only, truly successful symbols to have spun off from the symbology projects that sprouted in Europe in the mid nineteen twenties. These projects, whose goal was the creation of universal sign systems, developed in the wake of the semiotic theories proposed by

Ferdinand de Saussure and Charles S. Peirce—the same linguistic theories that later provided foundation for the various poststructuralist philosophies that developed in the nineteen sixties and seventies, and that led to the institutionalization of the idea of relational ethics. However, Saussure and Peirce, as well as all the others who have contributed to the naturalization of relational values, I would suggest, owe a previous debt to late nineteenth-century theoretical mathematician Georg Cantor. Cantor's invention of Transfinite Arithmetic set the whole moral and linguistic revolution in motion by removing infinities from the domain of God, and removing axiomatic completeness from the domain of mathematics. It all began with his first great discovery—a logical paradox he called the Diagonal Argument.

Subsequent to Galileo's discovery that a one-to-one correspondence between certain types of infinities creates paradox, and prior to Cantor's work on the subject, the task of explaining the character of infinities was left to theologians. Cantor, however, defined infinities as *objects*, as entities that can be greater than, lesser than, or equal to other infinities. To suggest that an infinity could be "actual," or treated as complete as opposed to "potential," in the way, for example, that the set of all natural numbers potentially grows as large as one wants it to, was a dramatic departure from past attitudes, and one that labeled Cantor a mathematical heretic. Redemption ultimately came (although too late for Cantor to enjoy it) with the eventual acceptance of his persuasively simple arithmetic: Two infinite sets are equal if they have the same cardinality—if, in other words, the members of one set can be counted by the members of the other.

38 The question that arose logically from Cantor's new

definitions for infinite sets was whether an infinity exists that cannot be put into one-to-one correspondence with the natural numbers. Cantor demonstrated that such a set exists with the Diagonal Argument. Since no mathematical expertise is required, I ask the reader to take a moment to absorb its elegant simplicity and stunning paradox:

$$
\begin{aligned}
1 &\rightarrow .\mathbf{1}\ 4\ 1\ 5\ 9\ \ldots \\
2 &\rightarrow .3\ \mathbf{3}\ 3\ 3\ 3\ \ldots \\
3 &\rightarrow .7\ 1\ \mathbf{8}\ 2\ 8\ \ldots \\
4 &\rightarrow .4\ 1\ 4\ \mathbf{2}\ 1\ \ldots \\
x &\rightarrow .y\ \ .\ \ .\ \ .\ \ \bullet\ \ldots \\
&\ \ldots\ldots\ldots \\
&\ \ldots\ldots\ldots
\end{aligned}
$$

Cantor set up the argument by taking as a set all real numbers that exist as points on a line between 0 and 1, and listing them in no particular order (the column on the right). He then "matched" each of these entries—counting them, in effect—with the list of natural numbers (the column on the left). (Imagine that these columns extend infinitely to the right and downward.) He then took each digit that fell along the diagonal line in this table (the numbers in bold face), and simply added 1 to each number. Thus the bold face numbers that read 1, 3, 8, 2... became the new numbers 2, 4, 9, 3..., which Cantor referred to as the "diagonal number." Logically, it seems, one would be able to take this diagonal number, place a decimal in front of it, and find it in the set of numbers between 0 and 1. (In this table, it would fall anywhere in the right-hand column.) In other words, since the set of numbers

39

between 0 and 1 includes any arrangement of natural numbers preceded by a decimal point, the newly constructed diagonal number should be a member of this set, right? Not.

This new number, it turns out, does not occur in the list. Stay with me: Our diagonal number is .2493..., so its first digit (2) is different from the first digit of the first entry in the right-hand column (the table's bold digit 1). The diagonal number's second digit (4) is different from the second digit of the second entry (the bold digit 3). The third digit of the diagonal number (9) is different from the third digit of the third entry, the fourth from the fourth, and so on forever. Thus, the diagonal number exists nowhere in the right-hand column. Cantor proved that the infinite set of natural numbers cannot be put into one-to-one correspondence with the infinite set of real numbers between 0 and 1. In simplest terms, what must be true is not true.

If all this makes you crazy, be assured that Cantor's theories once made a lot of people crazy. The chain of Cantorian discoveries that followed his Diagonal Argument suggested that, contrary to Pythagorean assumptions, it is irrational numbers, not rational ones, that behave "naturally," and that the traditional method of reasoning from axioms is limited; there will always be statements about the quantities defined by axioms whose truth or falsity cannot be proved. Thus, Cantor forced the mathematics community to rethink the foundations of its practice—and, in so doing, sparked a *Grundlagenkrisis* against which all other *Grundlagenkrisen* pale. The battle between the intuitionists who controlled the academies and Cantor's insurgent formalists remains the most vitriolic episode in the history of mathematics; Cantor's career was destroyed and his reputation not fully restored until Kurt

40

Gödel accepted axiomatic incompleteness in the early nineteen thirties, long after Cantor ended his life in a sanitarium— a sorry tale that gives credence to ancient accounts of the Pythagorean clash, which, of course, resulted from the similarly unwelcome effect of an intrusive diagonal.

Cantor's discoveries, of course, had ramifications beyond the world of mathematics. His relative infinities achieve definition only in relation to one another (greater than, lesser than, equal to), and defer their signification in the same way words define themselves according to Saussure: not in comparison to objects in the world, but through differences from one another, a process which infinitely defers truth value. This same semantic structure would come to shape Jacques Derrida's philosophy of deconstruction and Jacques Lacan's psychoanalysis, and, ultimately, the form of much contemporary art. The same time that the no sign entered popular vernacular in the late nineteen seventies and early eighties, interdiction became the primary aesthetic strategy of artists, manifest most explicitly, perhaps, in Barbara Kruger's photography-based compositions featuring verboten "objects of desire" interdicted by red bands of prohibitory text.

So, although the proliferation of the diagonal in the postmodern environment might lead one to believe that Van Doesburg prevailed over Mondrian, Van Doesburg's challenge to Mondrian's perpendicularity was not a challenge to the idea of the absolute, merely a realignment of the absolute along a dynamic, futurist diagonal line. The Prohibition Symbol, on the other hand, aspires to a better future through discipline. And, though we may rarely welcome the sight of it, we must admit that the red circle with diagonal slash does the job well. If the Holy Cross, by virtue of embodying the order of the

Christian cosmos, was the perfect emblem for the transcendent lifestyle to which the Christian subject was expected to aspire, then the prosaic Prohibition Symbol is, in a different way, perfect too. It embodies the idea of transgression, and emblematizes the idea of secular rule, reminding citizens that for the sake of social order, certain quotidian conveniences or vices would be denied. In this sense, the Prohibition Symbol is a product of the Cantorian revolution, making meaning in the context of relational contingencies, and only making meaning stick insofar as it has the social power to do so. Neither Mondrian nor Leonardo—nor even Van Doesburg, I suspect—with their aspirations to infect the world with relatively permissive virtue, could have foreseen the prohibitive social environment of the late twentieth century, where, in the absence of absolute virtue, virtue would be enforced absolutely by a little diagonal sign.

Over all

 things stand the heaven accident,

 the heaven innocence,

 the heaven chance,

 the heaven prankishness.

Living

"by chance"—that is the world's most

 ancient form

 of nobility—

 and this I restored

 to all things:

 I delivered them

 from their bondage

 under purpose.

●

FRIEDRICH
NIETZSCHE

Chance Art

Americans seem perfectly willing to take chances at the quotidian level of individual existence: Gambling is a growth industry, even in the Protestant midwest; a large percentage of the population blows cigarette smoke in the face of statistical reality; and hardly anybody blinks at projections by the Department of Transportation that one in seventy-five of us will die on the road. Philosophically, however, we are not so willing to concede that life is a crapshoot. One need only consider the popular explanatory industry that has grown up around the assassination of John F. Kennedy and the academic explanatory industry surrounding Marcel Duchamp's art, both of which, by chance, began in earnest in 1963. The proliferation of JFK conspiracy theories suggests a profound unwillingness to submit to the pain and anxiety generated by the public spectacle of real bad luck. And the theory industry that has grown in the wake of Duchamp's 1963 retrospective at the Pasadena Art Museum suggests an equally anxious response to the spectacle of indeterminacy in art.

The implicitly determinist misprisions of Kennedy's death and Duchamp's oeuvre should surprise, I suppose, given that today the idea of a chance-based model of nature and culture is hardly the subject of philosophical dispute. Indeterminacy is at the heart of the information age; the communications, insurance, investment, transportation, and nuclear-energy industries are built upon it. The chance-based cosmology that in the late

nineteenth and early twentieth centuries challenged the prevailing Western idea of a providential or determinist universe, i.e. one that is "meaningful," has been naturalized in the sciences of chaos, complexity, and evolutionary biology. Moreover, the chance-based technique that originated with Duchamp has been naturalized in the domain of art, following Allan Kaprow's happenings, Barry Le Va's scatter pieces, Vito Acconci's and Eleanor Antin's interactive performances, to list but a few examples. It was not the ardent admirer John Cage who most fully understood Duchamp's cosmos of "indifference," but Andy Warhol, whose repetitive scenes of Jackie at the time of her husband's assassination, like his slightly earlier images of car accidents laid over "tragic" Rothko-esque fields of color, add up as so many quotidian numbers on a chart, thereby depicting and embodying the idea of indiscriminate fate as foil to the idea of historical destiny.

Warhol's disaster paintings generally (and wrongly) have been taken as a critique of the culture that would so perceive its tragedies, and Cage himself sought to redeem the chance design of his music through recourse to Oriental metaphysics. In fact, most cultures have struggled to reconcile dearly held beliefs in cosmic design with intrusive manifestations of indeterminacy. Monotheistic cultures have tended to have the most trouble with chance, since they set the idea of pure luck against the idea of a providential cosmos. In ancient Hebrew culture, the obvious misfortunes that befell the chosen people were accommodated by the introduction (in the first century B.C.E.) of an apocalyptic literature in which the justice promised by the Sinai Covenant would be postponed to a later time. Shortly thereafter, the misfortunes that befell individual, virtuous Israelites were reconciled to providence by the intro-

duction of the idea of an afterlife, which postponed to a later time and place the just reward originally promised by the Yahwist Doctrine of Human Nature.

Chance has tended to be less a problem for polytheistic cultures; in ancient Greece, it was both accepted and denied. Responsibility for some chance events was parceled out to minor deities to whom one might appeal, but both gods and humans were subject to the surfeit of indeterminacy generally regarded as blind destiny or fate. And in the Taoist natural and unified cosmos, chance was both accepted and denied in a different way: Pattern was discovered in indeterminate nature, meaning found in the pattern, and value given to the meaning.

A purely secular and indifferent model of chance, however, has been a problem for every culture invested in the activity of discovering meaning in the patterns of history or nature. At different times and in varying ways, all cultures have been invested in the practice of augury—traditionally, the resolving of religious, political, and legal matters by means of reading the intentions of fate or divinity in the patterns of material nature (the roll of dice, the entrails of animals, the casting of lots, the *I Ching*, et cetera). Although such practices played an official role in most early and ancient cultures, few nontribal cultures sanction them today (though, in a sense, they survive in the obsessive scrutiny of statistics by modern bureaucrats). The gradual decline of augury in both the East and the West occurred over the several hundred years that mark the turn to the Common Era—roughly speaking, during the transition from ancient to Imperial China, and from the Old Testament to the New. The cause of this decline would seem due less to increasing public awareness of augury's unre-

liability than to increasing performance of augury by private individuals—and the resultant threat to ruling aristocracies and priestly castes.

With official disapproval of augury came official disapproval of augury's evil twin—gambling. It was condemned by Buddha, Confucius, Brahmin priests, Mohammed, Pliny, and the early Christian church fathers, while being celebrated by none. The acquisition of money and power by chance, of course, challenges the first principles of aristocratic and ecclesiastic cultures, which associate privilege and power with virtue and just reward. As social historian Keith Thomas has pointed out, gambling appeals to those low on the social ladder, who prefer to explain the discrepancies in the availability of just rewards by invoking the notion of secular chance. Whereas, logically enough, the doctrine of providence appeals to those high on the ladder, who benefit from the illusion that good fortune is deserved. Not surprisingly, gambling has been considered a social problem in almost all cultures—including our own—that associate status with virtue.

Gambling and augury date back to the cave, and no one can say exactly when the two parted ways. It is reasonable to assume, however, that few dedicated gamblers would have held a mystified view of chance for very long. When Blaise Pascal formulated a problem of odds on dice in correspondence with Pierre de Fermat in 1654, thus founding the calculus of probability, he did so at the urging of an inveterate gambler friend who, as it turned out, had intuited Pascal's result to within a fraction of one percent. In fact, the presence of rules that govern the occurrence of unpredictable events had been privately discovered just over one hundred years earlier by the Renaissance physician and mathematician Gerolamo Cardano,

whose appellation "The Gambling Scholar" was well earned. Though Cardano published over two hundred books on topics as diverse as algebra and child rearing, his 1526 treatise on the law of large numbers did not go to print. No doubt his personal history of unhappy confrontations with the Catholic Church persuaded him to keep what is now considered his most significant work under wraps—a theory of probability that has been called the greatest philosophical success story of all time, and which, by any standard, has proved to be the most reliable of natural laws.

Even so, when the idea of chance entered the domain of science in the seventeenth century with the dissemination of Pascal's formulations, mathematical proof of secular luck elicited barely a philosophical gasp, since Western mathematicians and philosophers consistently took probability as proof rather than refutation of providential design; the devoutly Jansenist Pascal himself used probability theory to infer the logical propriety of belief in God. Soon thereafter, the idea of divine design was seemingly confirmed by the regularities in Newtonian mechanics and further reinforced in the eighteenth century by the proposition put forward in Abraham De Moivre's famous *Doctrine of Chances* that statistical regularity is caused by intervention from on high. In the nineteenth century, Pierre Simon de Laplace made no claims for the specifically Christian God, but reified the fundamental construct of a determinist cosmos by proposing that a pantheistic, all-embracing spirit rules over all.

In De Laplace's cosmology, the inability to determine a single roll of dice or the particular birth of girl or boy was attributed to human ignorance, not lack of cause. Even Albert Einstein would take this conviction to the grave. Despite

49

Friedrich Nietzsche's eloquent advocacy of chance as the antidote for Apollonian malaise, Charles S. Peirce's conclusion that absolute chance is the irreducible factor of the universe, and the general late nineteenth-century anti-determinist wave that buoyed these philosophers along, it was not until the mid twentieth century that an intrinsically unpredictable model of nature achieved general acceptance in the scientific community, and that was after more than two decades of intense debate on the interpretation of discoveries in quantum physics—an argument Einstein could see was lost, but could not bring himself to concede to the victors.

<div align="center">✳</div>

In the world at large, however, the idea of a wholly chance-based cosmos has not been accepted yet. Today, the academy swims in the reconstituted Judeo-Christian mud of Karl Marx's historical determinism and Sigmund Freud's childhood trauma-caused construction of predestination. In popular culture, the sciences of chaos and complexity are redeemed as confirmations of cosmic order (though an order based on an Eastern cyclical model rather than the Western progressive one), and hardly anyone wants to accept the official conclusion that the insane, notoriously inexpert rifleman Lee Harvey Oswald could have wreaked such misery without any help. Oliver Stone's *JFK* emblematizes the desire to find purpose where there may be none. The 1991 film not only mythologizes the idea of conspiratorial cause, but would have us perceive Kennedy as the crucified Christ himself: For his dramatically lit autopsy scene, Stone borrows heavily from Caravaggio's Counter-Reformation painting *The Incredulity of Saint Thomas* of 1601-2; the post-assassination physicians probe bullet holes in Kennedy's body in exactly the same

manner that Caravaggio's doubting Thomas probes Christ's post-crucifixion wound.

And in the world of aesthetics, of course, Marcel Duchamp's attempts to reconcile the secular contingency of chance to the quasi-religious practice of art generally has been perceived as a nihilistic rejection of art itself—the Dadaist's anti-art gesture. Since the nineteen sixties, Duchamp has been glorified as the inventor of conceptualism, which has been conceived incorrectly as an art that transcends the concept of design and achieves cultural value by virtue of operating in the determining atmosphere of pure idea. As a consequence, even today chance-art is associated less with Duchamp than with artists who produce their art by means of supposedly irrational procedures. Jean Arp and André Masson are the most notable twentieth-century artists to traffic in this particular rhetoric of chance, along with Jackson Pollock—at least according to many of his critics, even though Pollock himself claimed never to have made anything by accident.

Arp employed accidental procedures in order to reify that which he perceived as an essential and redemptively indeterminate nature; Masson later adapted the Surrealist poets' automatic procedures to painting in order to reify the drives of that which Freud conceptualized as the naturally primitive and redemptive unconscious. Neither artist, of course, reified anything. They produced allegories—in Arp's case an allegory of "natural Nature," and in Masson's an allegory of the natural Mind, metanarratives that Pollock consciously combined and perfected. "Fortuitous art," then, might be a better term to describe the results of these artists' encounters with unseen natural forces. Although none of them participated, theoretically, in the rationality of formalist aesthetics, they each sub-

verted the moral neutrality of indeterminacy, since the results of their irrational procedures were, providentially, always good.

In fact, chance-art has been fortuitous since the very beginning. Pliny provides the earliest accounts of two types of chance-art, both of them legends from ancient Greece. The first is the tale of the block of stone that, when split open, revealed the image of Silenus naturally inscribed in its veins. This kind of art—discovered readymade in the ordinarily entropic design of clouds, gemstones, foliage, rock formations, and the like—is known to have been widely admired in Hellenistic antiquity, and was prized in both the East and West during the period of the Middle Ages. Although naturally occurring illusionistic representations have been perceived throughout history as evidence of the miraculous or marvelous power of God or nature, they have at times been analyzed as pure accident: In ancient Greece, Philostratus argued that the viewer projects the image onto the cloud in the same way the painter projects the image into pigments; in Renaissance Italy, Alberti theorized that the art of sculpture was born as a result of observation of natural anomalies in tree trunks and such, and Leonardo recommended wall stains as inspiration for landscape design. Since the Renaissance, however, chance formations in nature have provoked little theoretical or artistic interest. Although they have attracted popular attention as providential signs, particularly when the image resembles Christ or the Virgin Mary, the indifference may be due to the fact that chance images frequently fail to resemble an appropriately revelatory subject. Camel Rock, for instance, unprovidentially located near Santa Fe, New Mexico, stands out as the single natural monument, in a state chock-full of natural monuments, that is without mythological origin.

The second type of chance-art originates, according to Pliny, with the Hellenistic painter Protogenes, who, frustrated in his attempts to render the illusion of a dog's foaming mouth, flung a sponge at his panel, thereby achieving a perfect result. This kind of marvelous luck is known, courtesy the fractal nature of the universe, to every artist who has experimented with textures, specialized brush effects, or readymade materials to achieve an illusionistic effect. In antiquity, such lucky art techniques were thought to be the gift of Fortune, bestowed (rather conveniently) on only the greatest painters. In the twentieth century, the late TV-show artist Bob Ross made some of this luck available to even the most unskilled dilettante, via his half-hour shortcuts to painting the natural sublime.

In eighth-century China, a third and final type of chance-art arose in the form of what might be called the "assisted readymade." This type of art was the province of a few unorthodox religious adepts who intentionally relinquished rational control in their working procedures, often by recourse to alcohol. A drunken Wang P'o-mo (not a postmodern kind of guy, but "Wang the Ink-Flinger") sang and laughed as he splashed ink on a scroll, which he then smeared with his hands, kicked with his feet, and scrubbed with brushes. Occasionally, he soaked his topknot in ink, then butted his head against the paper. The irrational action-painting practiced by Wang and other T'ang and Sung Dynasty painters reportedly resulted in perfectly legible landscapes (no examples survive) that were taken by their contemporaries as evidence of these artists' Taoist harmony with the natural cosmos.

Metaphysical unity with natural forces was also the presumed consequence of twentieth-century irrational pro-

cedures in art. These procedures, however, somewhat mitigate the magic traditionally associated with chance-art: The supposed improbability of finding a face of Silenus in the veins of a rock makes discovering one there considerably more amazing than discovering that the torn pieces of paper in Jean Arp's 1917 *Collage Constructed According to the Laws of Chance* look like, well, torn pieces of paper. However, the art of Arp, Masson, and Pollock depended no less on the shock of recognition. For if the indeterminate natural forces that these artists purportedly captured were unavailable in the visible world, their determinate counterparts were plenty visible in the world of art. The invisible order of nature was the staple object of Modernist geometric abstraction, particularly of the ambient Synthetic and Analytic Cubism whose pictorial organizations these artists mimicked.

*

Arp, Masson, and Pollock developed an art idiom characterized by the irregularity of organic entropy, which allowed them to modify the planes and lines of geometric abstraction in precisely the same manner that naturally occurring forms of chance-art alter the more orderly representations they accidentally mimic: Just as we are aware of the fractal design of the rock in Camel Rock, we may assume that the image of Silenus, the mark of Protogenes's sponge, and the landscapes of eccentric Chinese artists retained the identity and irregular complexity of the natural materials, or the imprints of those materials, with which they were formed. In this sense, all types of chance-art are equally as allegorical as the twentieth-century versions. In pre-Columbian America, after all, Camel Rock was just a rock. As Philostratus observed regarding the practice of painting, chance-art is not in the object, but

in the imagination.

Philostratus's observation has broad application; it aligns chance-art with those late-twentieth-century theories of art related to perceptual expectation and gestalt psychology, and, in a general sense, with structuralist theories that propose the relativity of vision and signification. At its most fundamental level, chance-art, whether it arises spontaneously or is assisted by humans, achieves legibility in the way (according to information theory) that all art achieves legibility: Visual order is distinguished from a background of visual noise. The fact that the chance-art idiom incorporates a degree of that entropic noise makes its meaning no less distinct, nor its means of signification any less conventional. Thus, all kinds of chance-art, whether they aspire to depict nature as ordered or as indeterminate, deliver the same message—which goes something like this: Art is discovered and not invented; nature or God approves of, makes, and (for mysterious reasons) hides art; the mission of the artist is to find meaning, not make it.

Chance-art, then, purports to demonstrate overtly the validity of the underlying assumptions upon which a great deal of art, both Eastern and Western, covertly relies: that art, as the T'ang Dynasty theorist Chang Yen-yuan asserted, "proceeds from Nature itself, and not from human invention." This determinist model is articulated in Plato's ideal, Michelangelo's poems, and Clement Greenberg's formalism. It is implicitly manifest in Praxiteles's *Aphrodite*, Michelangelo's unfinished sculptures, Analytic Cubism, Wassily Kandinsky's early abstractions, Piet Mondrian's concrete art, and many places elsewhere. It is also manifest in the works of Arp, Masson, and Pollock, whose attempts to reconcile the idea of chance with

art was as blind an act of faith as Pascal's, since their art purported to redeem and naturalize the providential character and sanctity of art itself.

These artists' evil cousin, Marcel Duchamp, took the opposite tack, to destroy not art but the *sanctity* of art. Throughout his career, Duchamp sought to defeat the principle by which perceptual habits are formed—to prevent "memory imprints" from organizing visual information into pattern and the meanings pattern affords. His original project was to transform Cubism's and Futurism's concept of simultaneity from picture to design—to invest that mechanically cacophonous and implicitly redemptive concept of chance with literal indifference. To this end, he displayed randomly selected banal objects, such as bottleracks and bicycle wheels—works of art he discovered readymade in the domain of culture rather than that of nature—and later addressed the unpredictable contingencies involved in the unfolding of real time. In *Monte Carlo Bond*, for example, he sold bonds to those willing to invest in his performance at roulette, and enacted the piece during the 1924 and 1925 seasons in Monte Carlo. (He would have continued this work in later seasons, had his pocketbook not encountered the law of large numbers.) And his most famous work, the *Large Glass*, was developed, embellished, and altered over the duration of his career, not being completed until its three-dimensional version *Étant donnés* was installed in the Philadelphia Museum of Art in 1969, a year after the artist's death.

Duchamp's attempts to reconcile art to chance ultimately proved utopian, since his commentators have preferred to mythologize his art rather than to comprehend his design—focusing on the arcane objects and projecting onto them, in

turn, formalist aesthetics, iconographies of science, and thick descriptions of Marxist and psychoanalytic theory. Although recent theorists may correctly perceive Duchamp as a relativist, Duchamp did not propose, as some think, to transcend the idea of art or design; his achievement was to embody in his art the principle of contingency. He did not invent conceptualism, but, just as he claimed, *returned* art to conceptualism as it was "before Courbet"—before Realists aspired to transcend concept and design. What is lost in the current critical reverence for Duchamp the aloof, prescient philosopher is Duchamp the sharp, urbane artist: The secular gambling man of *Monte Carlo Bond* is transformed into a slightly more rakish version of Theodor Adorno. By denying the secular contingency of Duchamp's chance designs, contemporary theory has done for Duchamp what Pascal did for probability theory—and what Oliver Stone attempts to do for JFK's assassination.

Fifth-century B.C.E. Greeks had a name for the kind of bad luck that befell Kennedy. They called it "tragic fate." Despite the mathematical evidence that suggests the ancient tragedians might have got it right, Americans cling to Elizabethan dramas of betrayal and blood revenge: Bay of Pigs, CIA, FBI, Mafia, the man on the grassy knoll. And art theorists cling to a fantasy of Platonic order by constructing the idea of an ethical conceptualist art. Like conspiracy buffs pouring over and over the Zagruder film, they pour over Duchamp's unyielding readymades, transforming them into relics and Duchamp into myth, and reënacting the blind-faith attempts of Arp and Masson to demonstrate the naturally providential character of art. It is a testament to the effectiveness of Duchamp's designs that his objects remain opaque.

If, as literary theorist Morse Peckham once suggested, the function of art is to familiarize those perceptual orientations that prepare individuals to receive information relevant to survival, then the audiences of Aeschylus and Sophocles would have been better prepared than most Americans to confront the spectacle of fair Kennedy brought down by indiscriminate chance. They would have viewed tragic events as Aristotle suggested they be viewed—as occasions for pity and fear. Unlike American audiences, they might have recognized the pity and fear in Warhol's disaster paintings and not taken them as a critique. And instead of obsessively seeking meaning in Duchamp's objects, they might have grasped the absence of meaning in the world embodied in his designs—the world in which the desires of human beings for order and providence are routinely frustrated by the secular indifference of chance.

Deep Design

The ascent to the HEIGHTS of non-objective art

is arduous and painful . . .

but it is nevertheless rewarding.

The familiar recedes ever further and further into the BACKGROUND.

The contours of the objective world FADE more and more,

and so it goes, step
by
step
until finally the world—

"everything we loved and by which we have lived"—

becomes lost to sight.

No more

"likenesses of reality," no idealistic images—

NOTHING BUT A

desert!

●

KASIMIR

MALEVICH

New Mexico

It may be impossible to envision New Mexico without the intercession of Georgia O'Keeffe's depictions of it. In one way or another, O'Keeffe's inscriptions of the place precede almost everyone's experience of it. The style and iconography of her paintings have permeated much of New Mexico's material culture. She has shaped it visually by appropriating Native and Hispanic cultures to her own ends. As much as anyone, O'Keeffe is responsible for the reification of New Mexico, or at least its north-central section, as the embodiment of the Modernist abstract sublime and mystical symbol of redemptive nature. This is no small achievement, given the fact that just over a century ago much of this desert "wasteland" was gladly conceded to defeated Native American tribes.

Even more remarkable is the fact that Americans still cling to O'Keeffe's paradoxical inscription of desert sand as promised land, especially given the epistemic changes that have taken place since her time. The quasi-Biblical character O'Keeffe and fellow Modernists bestowed on New Mexico, of course, is built upon and written over a nineteenth-century Romantic nature, which is written over a colonial Spanish culture, which is written over a Native American culture, which is written over the lost culture of the Anasazi. Today, however, the idea of a chaotic post-atomic universe has been irrevocably scribbled over all; the simple order implicit in the Modernist

notion of the abstract sublime has given way to the complexity of disorder, and the purity of redemptive nature has been tainted by insidious toxicity. Ironically, this epistemic change originated in Modernist New Mexico's own backyard.

<p style="text-align:center">*</p>

As the crow flies, Los Alamos is twenty-five miles from the popular tourist destination of Santa Fe and fifty-six miles from smaller, equally picturesque Taos. The flavor of Los Alamos, a city of scientists which is said to hold the largest per capita population of Ph.D.'s in the world, is a far cry from that of Santa Fe and Taos, which present themselves as old-world adobe villages and utopian refuges from the sterility of logical thinking. Its ambient architecture is alternately high-tech, militaristic, and banal; the clean streets, orderly arrangement of barracks-style residences, barbed-wire fences, and ominous guard towers that surround the secret and queerly shaped industrial buildings of the Los Alamos National Laboratories reflect a regimented social temperament that has made this small city the brunt of a local joke—"the town with no right brain." (I once received a speeding ticket there for going thirty-two in a thirty-mile-per-hour zone.)

Robert Oppenheimer gave birth to Los Alamos when he brought the top-secret Manhattan project to the site in 1944. He had selected one of the loveliest spots on the globe, a small plateau just high enough on the east side of Mt. Pajarito to support tall pines. To Oppenheimer, it was the perfect place for an isolated, utopian colony of scientists to develop the atom bomb. To the west, the infinite expanse of New Mexico's high desert rises to the rugged Sangre de Cristo range. The relatively short hike from Los Alamos to the top of Pajarito provides a magnificent vista of Valle Grande, the largest ancient

volcano caldera in the world, and an overview of Mortandad Canyon, home to Cave Kiva, decorated with drawings by the Anasazi Indians sometime between the thirteenth and fourteenth centuries—as well as to a restricted section of pined canyon floor which remains contaminated by radioactive waste discharged from the National Laboratories during the nineteen fifties. Oppenheimer had cavorted there on horseback as a young man.

At night, Los Alamos enjoys the high-voltage canopy that decorates all of desert New Mexico; when the sun goes down, the earth's atmosphere seems to disappear, leaving one in direct confrontation with outer space. Looking east from the edge of the plateau, the city lights of Santa Fe shimmer brightly, and to the north, one can glimpse a faint twinkle of Taos. Oppenheimer's bastard paradise provided perhaps the perfect setting for the Romantically-inclined theoretical physicist Mitchell Feigenbaum who, while working in Los Alamos in the mid nineteen seventies, made his famous contribution to Chaos theory: the discovery of geometric convergence, or period doubling, in calculations of quadratic-difference equations, a sort of fractal math. Feigenbaum's habit of pacing through the city's deserted late-night streets, obsessing, presumably, over the perplexing complexity of an unpredictable world, is now local legend.

When Feigenbaum was in post-atomic Los Alamos defining the nature of Nature as infinitely bifurcating, O'Keeffe was still living just over the hill in Abiquiu, the tiny Hispanic village to which she had retreated from the social pressures of New York and Taos long before. The infirmities of age had only recently stilled production of her version of the natural world—the integrally smooth shapes and surfaces she discov-

63

ered in every plant, animal, and geological form she had painted for nearly fifty years—and her reputation was increasing exponentially throughout the United States. Although the Modernist nature that O'Keeffe had most fully conceptualized in New Mexico had passed into obsolescence, its legacy was being vibrantly preserved in Taos and Santa Fe, where to this day she remains something a patron saint.

Like Feigenbaum, O'Keeffe had her own eccentric nighttime habit. Cradled atop her flat-roofed adobe home, she would fall asleep pondering the nearly tangible cosmos above. O'Keeffe's peaceful, flat-on-her-back submission to sublimity stands in sharp contrast to Feigenbaum's frenetic prowls. Feigenbaum would not have been pondering the heavens; his inspiration was Goethe, not Newton, and the predictability of stellar motion offers little inspiration for ruminations on nonlinear dynamics. Feigenbaum's mind was on the turbulent complexity of phenomena he could more easily observe on earth—the dripping faucet in his sink, the curling smoke of his cigarette, the clouds he looked down upon from the summit of Pajarito. O'Keeffe looked up and beyond to the cosmic mysteries of essential order; Feigenbaum looked down and around at the deep complexities of quotidian disorder.

<center>✳</center>

One of the touchstones of Chaos theory is meteorologist Edward Lorenz's concept, technically known as Sensitive Dependence on Initial Conditions and colloquially referred to as the Butterfly Effect: A butterfly stirring the air in Tokyo today will affect storm systems in New York next month. If the distance between Feigenbaum's and O'Keeffe's views of Nature can be attributed to the atomic culture that generationally falls between them, then the flapping butterfly who brought this

firestorm to the landscape of New Mexico would be its doyenne of Modernist culture, Mabel Luhan (previously Mabel Dodge and Mabel Sterne). This heiress, writer, and avant-garde social butterfly, who began her reign over northern New Mexico's *esprit moderne* in 1916, was not the first Modernist to colonize the state. She was, however, the first to "discover" its spiritual qualities—and to gentrify and advertise them. She penned homilies to the landscape and native culture and in the nineteen twenties and thirties encouraged and frequently financed the journey there of hundreds of the world's cultural elite, including O'Keeffe.

Painters and writers had been arriving in northern New Mexico since the Santa Fe railroad opened it up in 1880, well before Luhan began importing *culturati*. Most early pioneers, however, ignored the landscape in favor of cowboy dramas and sentimentalized depictions of waning tribal life. Late nineteenth-century landscape painters had little interest in the flatlands of New Mexico. Albert Bierstadt passed it by, and Thomas Moran generally neglected the desolate plateaus during his brief stay in Taos. Instead, he recorded the more verdant mountain vistas that lent themselves to Romantic formulas for depictions of the New Eden.

The idea of presenting New Mexico's desert terrain as an allegory of Nature's paradise apparently did not occur to the state's nineteenth-century inhabitants. This inscription arrived with Luhan's cosmopolitan colonizers, who adapted Modern forms to the desert and the desert to Modern form. The sublime void that occupied the center of Romantic landscape compositions, usually framed by geological features, flora, and historical details for depth, was replaced with a more abstract version of sublimity that filled the canvas. The emotional

65

crescendos of the Romantics were supplanted with what Kasimir Malevich had described as the "desert of pure feeling." Finally, this abstract sublimity was flavored with the "primitive" psychic space first proposed by Sigmund Freud.

Although O'Keeffe is the Modernist most identified with New Mexico, she is not Mabel Luhan's most legendary cultural conquest. After reading *Sons and Lovers* and *Psychoanalysis and the Unconscious*, Luhan became convinced that D.H. Lawrence would be the one to unlock the secrets of New Mexico's pueblo culture and, as a bonus, to recover the "lost Atlantis" of her own soul. To persuade him to make Taos his dreamed-of utopian artists' colony Rananim, Luhan mounted a persistent letter campaign and eventually resorted to witchcraft, sending Lawrence's wife a necklace steeped in Indian magic, and drawing her own power "into her solar plexus" in order to will him there.

Lawrence was not disappointed when he arrived in 1922. He later described his encounter with New Mexico as a "shattering force," the greatest experience of the "outside world" he ever had. After searching the globe—Ceylon, Sicily, Australia, Tahiti—for something truly religious, only in New Mexico did Lawrence find the "vast, old religion that lingered in unbroken practice, the old, old root of human consciousness" that he so wanted to exist. Carl Jung found it, too. In 1925, he breezed through New Mexico just long enough to interview a tribal elder atop a roof at Taos Pueblo and to discover a direct connection to the roots of all human life which, according to Jung, was occluded in European culture by rationalism.

Neither Lawrence nor Jung concerned themselves with the secular complexities of native culture, nor had they

any admiration for those natives who interrupted the smooth-
ness of tribal integrity by interacting with their Hispanic or
Euro-American colonizers. (Lawrence particularly despised
the "low dog Red Indian who slinked around Taos plaza" or
sold baskets, and was loathe to sit at the dinner table with
Native American Tony Luhan, whom he felt had betrayed his
race when he married the thoroughly Anglo Mabel.) This
selective vision allowed Lawrence and Jung to discover in New
Mexico an unsullied Rousseauean primitivism possessing none
of the hedonistic sensuality of Gauguin's Tahiti, a virtuous
nobility and essential spirituality untainted by human desire.
Not surprisingly, each suggested that the source of this pure,
uniquely ancient culture might be the austere and expansive
landscape in which it had developed. Jung urged those who
would know Native American religion to stand in the clear air
of a solitary plateau and exchange knowledge of the world for
"the horizon that seems immeasurable, and an ignorance of
what lies beyond it."

If it were Lawrence and Jung who originally discov-
ered the sublimity inherent in New Mexico's desert infinitude,
it was O'Keeffe who most fully exploited the built-in iconog-
raphy of the landscape and, in so doing, transformed north-
ern New Mexico into an American myth. The Modernist
painters who arrived concurrently with O'Keeffe on her first
visit in 1929—Andrew Dasburg, John Marin, and Marsden
Hartley among them—produced many fine landscapes in vari-
ations of Cubist, Futurist, Syncromist, and Fauvist styles.
Although their depictions are still ambient in New Mexico cul-
ture, their inscriptions have been neither as pervasive nor as
indelible as hers. It was O'Keeffe's genius to acknowledge the
oceanic past in New Mexico's landscape and to adapt its vast-

ness and extant biomorphic adobe structures to the Surrealist idiom of deep space and further to sanctify this idiom by eradicating Surrealist sensuality, replacing it with the mystical purity of the abstract sublime.

Indeed, New Mexico's landscape is a readymade allegory of the Surrealist's memory-littered unconscious, with volcano cones and ancient fields of black lava, sea-creature and dinosaur fossils, archetypal rock paintings, pristine stretches of pure white sand, foothills polka-dotted with sage, natural hot tubs bubbling in fissured mountains, wind-carved Precambrian outcrops, and striped canyon walls that trace the erratic history of the Rio Grande—all juxtaposed in hazeless, lunar stretches of dust and rocks. It has been made even more surreal (and more sublime) by the recent addition of the Very Large Array, an ominous collection of gargantuan dish antennas that stretch across twenty miles of the southwestern plains in order to listen to outer space (under the auspices of the National Radio Astronomy Observatory) and by the addition of Walter De Maria's nearby *Lightning Field* of 1971-77, a grid of 400 twenty-foot-high stainless-steel poles that aspire to "connect" with the heavens via electrical storms that frequent New Mexico's skies.

New Mexico's desert seems predisposed to revelation as well, attracting in recent years a multitudinous migration of almost every religious sect in the world—from Eastern to Western, Baptist to out-of-body. O'Keeffe herself had dressed as St. Jerome in wide-brimmed hat and cloak and lived in ascetic isolation at Abiquiu, frequently roaming the surrounding ancient seabed to gather the bleached and weathered skulls and bones she called "desert flowers." There she translated the materiality of Native American horticultural religion and the brutal *Penitente* culture of Spanish New Mexico into a benign

promised land, replacing the local tribe's hierarchical magic and the Hispanic's tragic rhetoric of the sacrificial body with a democratic and reductive version of a Protestant-type Peaceable Kingdom.

Despite some feminists' insistence on the bodily content of O'Keeffe's biomorphism, the Midwestern-born puritanical O'Keeffe, who disdained early feminist readings of her work, actually de-eroticized her biological idiom. In New Mexico, she sensed the connection of the land's primordial iconography (and the solipsism inherent in its 360-degree horizon) to the infinite psychic space and the amoebic creatures of Salvador Dali, Yves Tanguy, and Joan Miró. She further identified the vast internal space of the unconscious with immaculate Modernist mysticism, and wed a biological but desiccated nature to the Garden of Eden. Just as Lawrence and Jung had exploited the rigorously puritan (but non-Christian) character of Native American culture to construct an ascetic landscape, O'Keeffe used the desert landscape to reconcile bodily primitivism to her Midwestern sensibility. As certainly as Lawrence and Jung took the Tahiti out of primitivism, O'Keeffe took the sex out of Surrealism.

Thus, the artifacts of the Anasazi, who once inhabited the caves and canyons of New Mexico, are largely omitted from the landscapes and imagination of the Modernists. For these artists and writers, New Mexico was, in Archibald MacLeish's phrase, "A country in the mind, and so eternal." The pots and stone edifices the Anasazi left behind provided unwelcome evidence of pre-Columbian history and cultural mutability. With this occlusion in place, the Modernists were able to discover in New Mexico a transhistorical culture set in a benign intransitive Nature that eradicated the sins of the flesh

69

and the transgression of cyclical biology. This puritanism accounts for O'Keeffe's personal apotheosis into an "all-American" icon—and for the peculiar worship of non-Edenic nature, so perfectly emblematized in weathered bones, which as a consequence of O'Keeffe's paintings pervade New Mexico's colonial culture today.

Ironically, the role of natural paradise that the Modernists imposed on New Mexico contributed inadvertently to the demise of this very inscription. Once Luhan had set it in motion, the fabled Taos-Santa Fe locus became something of a Modernist vortex—attracting not only artists and writers but, by virtue of the romantic and fashionable ambiance they created, the young and affluent Robert Oppenheimer, who later returned with the Manhattan project in tow. The fallout from the bomb that Oppenheimer constructed in Los Alamos, of course, transformed New Mexico's playground absolutely—and, apparently, the text of the rest of the world as well.

*

In the afterglow of Hiroshima and Nagasaki, it was apparent even to then-Secretary of State Henry Stimson that, as he stated, "The world has changed." In the short-lived euphoria that immediately followed the success of the atom bomb, it appeared that a simple exchange had taken place: Instead of Nature holding secret power, humankind held Nature's secret. Indeed, a euphoric Jackson Pollock—himself having looped through New Mexico to learn of ritual painting from Native Americans—proclaimed, "I am nature," and, with ensuing *tristesse*, poured skeins of paint that seem to record the seismic cries of an existentially anguished Nature.

It has been suggested that the fear of nuclear holocaust and the consequent atmosphere of cold-war rhetoric

prompted the epistemic shift toward postmodern critical practices that began in the nineteen sixties. In fact, this transition is grounded in the post-atomic construction of Nature that is consequent to actual rather than potential disasters. Although fear of annihilation grew with nuclear proliferation, the impact of that fear was soon quietly surpassed by the anxiety generated by the radioactive landscapes that atomic and nuclear explosions leave behind. Invisible, malignant poison, first disseminated on July 16, 1945, at Trinity Test Site, across the pristine white sands of New Mexico's southern plains, spread rapidly to other sites, and fear of its invisibility, as well as that of other pollutants impossible to detect with ordinary human senses (or without technological assistance), rendered all of Nature suspect. Consequently, fear of toxic landscapes transmogrified into a pervasive cultural paranoia that manifests itself as the radical critique of Nature's text and of texts that naturalize Nature.

It was not fear of the end of the world that engendered the philosophical shift; eschatological discourse had been in play since before the Christian era. Instead, the postmodern critique is grounded in a fallen, radically transitive, post-apocalyptic Nature, which finds its metaphor in an innocent-looking landscape with a hidden catastrophic agenda. Nature, of course, had fallen before, but the modern era's construction of redemptive Nature—encouraged by the discovery of the New World, but not fully institutionalized until nineteenth-century Romanticism superseded the Church—repudiated the long-standing Hebraic-Christian construction of Nature as fallen. The cyclical character of nature had contradicted the Hebraic-Christian idea of progress toward apocalyptic redemption, and thus was held in contempt. Its evil was sym-

71

bolized by a desolate and terrifying desert wasteland that tests spiritual resolve.

Thus, the irony of New Mexico. Just as John Constable's rustic landscapes were apotheosized at exactly the moment British enclosure laws rendered that landscape antique, O'Keeffe's reification of New Mexico as the embodiment of the philosophical tradition that holds Nature to be essentially simple and good was apotheosized at the very moment scientific and intellectual discourse repudiated that model. Despite well-placed attempts by contemporary artists such as Richard Misrach, Peter Goin, and Patrick Nagatani to de-aestheticize the inherent abstraction of the desert void— and despite the fact that the post-apocalyptic landscape was born in Modernist New Mexico itself—for the broad American public the postmodern inscription of New Mexico has not supplanted the Modernist one. Walter De Maria's *Lightning Field*, which leaves the Modernist cosmology intact, was the last inscription of New Mexico's landscape to draw widespread attention. And today, the popular idea of desert New Mexico remains limited to its role as quasi-holy natural paradise, as it sustains for the nation the dream of pre-apocalyptic, redemptive Nature.

Culturati continue to flow into Taos and Santa Fe, joined by a collateral stream of Hollywood *glitterati* and a veritable flood of dentists, developers, and trust-fund babies who manifest their nostalgia for the décor and ambiance of an antiquated idea of nature as they advocate tribal immutability, legislate adobe-look development, frequent organic restaurants, costume themselves as early Modernist colonists (courtesy Ralph Lauren), languish on hand-wrought furniture, decorate with desert-bleached bones, and compete with one another

72

for plate-glass views of the desert sublime. At night, however, Los Alamos shimmers ominously on the plateau nearby, reminding those who would follow Jung and trade knowledge of the world for an ignorance of what lies beyond it—or who would recede ever further into Malevich's non-objective desert of pure feeling—that Taos and Santa Fe survive less as intransitive adobe villages than as manifestations of America's seemingly inexhaustible capacity for denial. As Feigenbaum's Los Alamos observations and calculations suggest, nature may be neither good nor simple, but indifferent—and more complex than most Americans dream.

73

Inanna spoke:

I *bathed for the wild bull,*

I *bathed for the shepherd Dumuzi,*

I *perfumed my sides with ointment,*

I *coated my mouth with sweet-smelling amber,*

I *painted my eyes with kohl.*

He *shaped my loins with his fair hands.*

 The shepherd Dumuzi filled my lap

 with cream and milk,

He *stroked my pubic hair,*

He *watered my womb.*

He *laid his hands on my holy vulva,*

He *smoothed my black boat with cream,*

He *caressed me on the bed.*

NOW I *will caress my high priest on the bed,*

I *will caress his loins, the shepherdship of the land,*

I

WILL

decree a sweet fate for him.

●

ANCIENT SUMERIAN

HYMN

The Showgirl

Any feminist daring to live in Las Vegas must come to terms with the city's most public icon of prosperity and permissiveness: the showgirl. For many, the showgirl is the quintessential objectified female—and, theoretically at least, not much else. The primary function of this elaborately costumed human mannequin is to present her body in frontal display as she strides gracefully down staircases and sideways across the stage, while keeping enormous headgear balanced. However, when the music swells, the curtains part, and the flock of statuesque, bare-breasted beauties, resplendent in auras of rhinestones and feathers, advances implacably toward us in measured processional, down temple steps and onto the stage, we are transfixed—not only by the spectacle, but by the showgirl's unwavering, mascaraed gaze. At once, our visual privileges as members of the audience are reconstituted: The invisible "fourth wall" that in the modern era separates the audience from the image, and that is critical to the mechanics of voyeurism, is relinquished in favor of reciprocal confrontation. Theater is transformed into ritual. We enter an older discourse in which we are participants rather than simple observers, responding to the showgirl's gaze as well as to her display.

This reciprocal gazing subverts and somewhat mitigates the standard feminist reaction to the spectacle of objectified women. One need attend only a few showgirl revues to

realize that the fantasy indulged in by much of the audience is not the fantasy of choosing and possessing, but rather the fantasy of *being chosen*—by the biggest, bustiest, most spectacularly bountiful woman in the house. This type of interaction is not easily theorized within the abstract model employed by most institutional feminists; neither Jacques Lacan's Freud-based theory of the gaze, in which scopophilia is conceptualized as an unconscious drive toward mastery, nor Jean-Paul Sartre's phenomenological "look," which insists upon the voyeur's sense of shame and humiliation, will work in this theatrical setting. The traditional model of the psychosexual gaze proposes a one-to-one correlation between masculinity and voyeurism, and between femininity and exhibitionism, and thus conceptualizes spectacularity only in terms of dominance and submission.

The showgirl revue, however, is less the voyeur's smorgasbord than a public ritual of courtship in which the female is on more than equal footing with the male—a contemporary reconstruction of those ancient Sumerian rituals in which the principal deity is that primary goddess whom feminists never seem to find when they seek the "goddess within": Inanna, Queen of Heaven, sometimes referred to as the Great Whore, and counterpart to the Great Mother, to whom so many contemporary feminists seemingly gain easy access. Actually, Inanna is among the first deities of any kind—one of the first *gods* in recorded history. She embodies pre-Romantic sexuality. The patroness of kisses and masturbation, prostitutes and promiscuity, she does not flinch at the taboos of bestiality and incest, counting horses and her own brothers among her numerous lovers. She is a fierce warrior who wears black clothes, gold bracelets, and always mascaras her choosing eyes. Her favorite toy is a skull. Like her successors Ishtar, Astarte,

and ultimately the showgirl, Inanna is spectacular, a creature of the eye. Emulating the bird of paradise or the peacock, she spreads her feathers and presents herself as the emblem of what scientist Simon LeVay has characterized as *proceptive* sexual behavior, as distinct from *receptive*. Inanna always chooses, even as she is chosen.

Given the blatantly pre-Romantic, and indeed pre-Christian cultural roots of the showgirl, it should not surprise that she became embroiled in the controversy over the imposition of family values on Las Vegas culture that took place in the nineteen eighties and early nineties. This controversy, of course, was but a local manifestation of the larger feminist and fundamentalist agendas that sought and continue to seek to suppress the discourse of spectacular sexuality in the name of political correctness and moral propriety, respectively. In these agendas, courtship behavior takes place only in private and ideally is replaced by speech, the most extreme example being, perhaps, Antioch College's sexual-conduct code: May I remove your blouse? May I touch your breast? To the same end, paternal or maternal behavior—what might be called a discourse of virtue— is publicized in the attempt to transform a polymorphous nation of libidinous women and men into a monolithic nation of monogamous nurturing couples bound by matrimony or, at least, romantic love. Patriarchal fundamentalists, of course, would have women be virtuous mothers only of children; while matriarchal feminists would have women be virtuous mothers of everything. But when it comes to the public behavior of women, both of these groups privilege any form of maternal behavior over spectacular sexuality, any kind of madonna over Madonna.

The critique of spectacular sexuality is nothing new. For more than a century, critics who defend women have found

themselves in opposition to people who defend sex, and celebrants of female "impropriety" have been caught in the web of patriarchal and matriarchal morality. This was certainly the case for Lydia Thompson and her British Blondes, who established in America the tradition of burlesque out of which the showgirl eventually emerged. When Thompson and her troupe arrived in New York in 1863, they introduced a blend of raucous humor and blatant sexuality to which their audiences were, to say the least, unaccustomed. The early reviews in the New York press flowed with approval for Thompson's daring eroticism and her ironic send-ups of respectability. But mainstream reaction abruptly turned as clergy, moralists, and suffragettes gathered forces against her. This scenario was repeated in Chicago during Thompson's first tours there in 1869. Early on, *Chicago Times* editor Wilbur F. Storey lavished praise on her production; but upon her return only ten weeks later, he lambasted Thompson and her troupe by charging, among other things, that they were "mere vehicles for the exhibition of coarse women and the use of disreputable language."

Storey, however, would have been better advised to acknowledge Thompson as a groundbreaking feminist. Thompson initiated a tradition of burlesque in which the shows were organized around women with distinctly assertive personalities—who often contributed to writing and production, and whose humor consistently challenged popular ideals of feminine propriety. The lag between initial positive and subsequent adverse reactions to Thompson's productions may have been due to the gradual realization that the subversions she and her colleagues acted out not only exaggerated, but perhaps contributed to the changing role of women in the broader culture. Indeed, Thompson's response to Storey's criticism did little

to assuage public anxiety. She lay in wait with some theatrical cohorts outside Storey's home; when Storey emerged, Thompson's publicist restrained the editor's arms while Thompson and another actress soundly whipped him with riding crops. After being charged with assault and fined $100, she explained to her fans: "They were women whom he attacked. It was by women he was castigated." This translation of spectacular power into political action was, no doubt, the very sort of thing that the guardians of morality feared.

<p style="text-align:center">*</p>

The earliest version of today's showgirl—silent, spectacularly costumed—first appeared with the onset of World War I, in the new-style revue productions at the Folies Bergère in Paris. (Burlesque had long since lost its female personalities, its punch, and, consequently, its subversive power.) Almost immediately, Florenz Ziegfeld Jr. introduced the showgirl to New York, modifying her look to better suit the WASPY standards of the legitimate theater crowd to which he tailored his shows. He selected taller, more slender physiques, and engaged respected fashion designers to create the costumes. Ziegfeld wanted a glamorous "girl next door" who was more aristocratic-looking than the plump petites he had seen parading in Paris and gyrating in cooch dances at ribald working-class burlesques in New York. His paradigm quickly became standard and has been modified only slightly since. As a consequence, today's Las Vegas showgirl seems more quaint than exotic—as archaic as Inanna and as campy as Ziegfeld's high glamour itself. Nevertheless, some 600,000 tourists a year are enticed to see gentrified nudity paraded on stage. It is a testament, perhaps, to Las Vegas's function as a refuge from American puritanism that during the family-destination decade, the few civic-

minded casinos that experimented with adding tops to the showgirl costume found that business fell off precipitously, and quickly returned to bare breasts.

Nudity is, in fact, one of the essential features of the showgirl's appeal. Bill Moore, whose *City Lights* revue ran unchanged for over a decade at the Flamingo Hilton, has eloquently described his physical criteria: "Boobies . . . we like big boobies, because in general we think men like big boobies." However, Fluff Le Coque, whose *Jubilee* continues to play at *Bally's*, has a different standard: "Small and firm . . . we want the girls to have a nice body and small, virginal bosoms." The costumes, of course, are designed to emphasize the nudity of the chest, and more recently of the derrière, as much as possible. By exploiting a principle seemingly first discovered by Donatello, whose fifteenth-century bronze of a curvaceous David is all the more naked for his boots and cap, the excessive ornamentation of the showgirl's costume sets up expectations at the same time it violates them—an internally closed system in which the striptease is compressed into iconic form. Show*boys*, too—in troupes such as the Chippendales and Thunder from Down Under—use the same device, but with less ornate spectacularity: cuffs and collar, but no shirt in-between.

Nudity, of course, has always been central to the spectacle of feminine impropriety; indeed, nudity can exist only *within* a discourse of propriety. Before Lydia Thompson introduced Americans to the impertinence of self-conscious female display, the pirouettes of balletic dancers had scandalized audiences with shocking glimpses of legs fully covered by tights. But it was Thompson's troupe and others like it that prompted the call for anti-burlesque legislation. The most sustained attack came from women's rights activist Olive Logan, a per-

80

fect "church-lady," who took to podiums and issued editorials in feverish attempt to prevent theaters from promoting the "nude woman." Logan's puritan fervor is indeed ludicrous in light of the fact that nude women were nowhere to be found on the nineteenth-century stage. Thompson and other actresses like her were forced to appear in "britches' roles" to exploit even the limited exposure afforded by the skimpy tunics and tights worn by classical male heroes. At that time, the closest one came to seeing skin was when the high kick of a Parisian cancan dancer exposed the few inches of nude leg between the top of an over-the-knee silk stocking and the bottom of a mid-thigh-length ruffled pantaloon. Apparently for Logan and her coalition of ministers and public officials, the mere shape of female anatomy constituted a pornographic level of exposure.

Of course, actual defrockment, or what might be called *naked* nudity, ultimately found its way onto the stage, but only under cloak of the ersatz *beaux arts* tradition known as the *tableau vivant*. This frivolous practice of posing live models, or oneself, in imitation of well-known paintings or sculpture began as a fashionable diversion for aristocrats in the late eighteenth century. In the nineteenth century, these living pictures were adapted to the theater, quickly becoming standard fare in Europe and abroad. Although the female models always wore "fleshings"—toe-to-chin skin-colored tights—those theater managers who deigned to present, say, William Bouguereau's *Nymphs* rather than Emanuel Leutze's *Washington Crossing the Delaware* frequently were hauled into court. In the early twentieth century, however, decency leagues relaxed their standards of propriety at about the same time that the female form came to be thought of popularly as expressive of "aesthetic principles" in and of itself. Thus, references to famous works of art

81

were no longer needed to give the displays of divine perfection the air of legitimacy. Tableaux became more fanciful, elaborate, and glamorous at the hands of production managers and set designers. Women were showcased as popular versions of the goddess of love: cupidlike huntresses with bows, wood-nymphs in trees, human ornaments hanging from gigantic chandeliers.

In effect, then, the showgirl is not so much the residue of the comedienne or the dancer as she is the final evolutionary stage of the *tableau vivant*. Perhaps it was this implicit condition of being a work of art that enforced the unwritten prohibition against movement on the part of the nude. The British had a law which permitted nudity on stage only on condition that the model remain absolutely immobile. For Flo Ziegfeld, to have a nude in motion simply would have been in poor taste. No doubt Ziegfeld wished to distinguish his shows from the burlesques in which shimmy dancers and strip artists were in considerable motion. Although he featured thousands of scantily clad show-girls over the course of his career, the totally nude bosom remained confined to static tableaux that were visible on stage only for a few fugitive moments when a curtain briefly parted. While the high-style, bare-breasted showgirl had already begun her familiar walking parade in Paris by 1918, she does not begin to stride in America until she arrives in Las Vegas in the late nineteen fifties—and then only after *Playboy* magazine, with its own concept of the sexy "girl next door" and its cir-culation of nearly one-million households, had paved the way.

In this final manifestation of the showgirl, all vestiges of Bouguereau are gone, yet the fine-art pedigree remains. Of course, the showgirl's original prototype is much older than a neoclassical nymph, and more archaic than a Greek Aphrodite. Inanna first emerged as a cuneiform sign, at that moment of

82

civilization when magical objects were transformed from fetish into icon, and the ritual of courtship inspired an iconography of power. Although Inanna is frequently depicted with the attributes of grain and full storehouses, her bounty signifies prosperity, not fertility. Procreation and generation were patronized by various important mother goddesses, and despite attempts to redeem Inanna as a Great Mother—through prejudices first imposed by nineteenth- and early twentieth-century patriarchal anthropologists and historians, and recently by matriarchal feminists—Inanna, as historian Paul Friedrich has observed, was never maternal. She was a *sex* goddess, devoid of both romance and virtue.

Inanna's spectacular sexuality did not transgress the proprieties of ancient Sumerian culture. She was at the center of a religion that proposes redemption through power, not virtue. (Christianity introduces the notion of redemption through virtue.) Inanna's showgirl counterpart, on the other hand, transgresses twentieth-century transcendental ideologies point by point—by virtue of her lack of virtues—but she does so only marginally today. She is confined to Saturnalian venues, where, even there, she lacks the aggressive voice of women in early burlesque. As a consequence, she poses little threat to the proprieties of puritan America. Nevertheless, in her triumphant spectacle, the showgirl serves as foil to those who would limit the controversy of the problematic relations between the sexes to a discourse of nurture, and who would redeem woman at the expense of sexuality. As such, an encounter with the showgirl entails coming to terms with a kind of sexual politics that is not preconditioned on feminine virtue, but is grounded, as it should be, in social relations of power—as any feminist daring to live in Las Vegas would know. 83

And She Gathered

All before Her. And She made for them

a sign to See.

And lo they saw a Vision.

From this day forth Like to like in All things. And then all that divided them merged. And then Everywhere was Eden Once again.

●

JUDY CHICAGO

Sexual Politics

It's baaaaaack! This time, however, Judy Chicago's *Dinner Party* purportedly has *arrived*. Ensconced as the centerpiece of a group exhibition called "Sexual Politics" at the Armand Hammer Museum at UCLA (April 24–August 18, 1996), this quasi-feminist roadside attraction is provided with an entourage of artifacts produced by some of the most significant artists of the nineteen seventies, eighties, and nineties. The grandiose production is organized by the respected feminist historian and theorist Amelia Jones, and comes complete with a thick scholarly catalogue, tape-cassette guide, big pink banners along Wilshire Boulevard (I love those banners), and enough writing on the wall to terrify Belshazzar—all the accouterments of canonical gentrification.

Instead of making the *Dinner Party* more palatable, however, the full-court presentation makes it all the harder to swallow. We are told that the chorus of over fifty supporting artists is not *intended* to glorify Judy Chicago, although in effect, of course, it does. Curator Jones comes not to praise the *Dinner Party* but, as she states in the catalogue, merely to place it in context—at the center of feminist art history—justifying the whole endeavor by citing the *Dinner Party*'s populist following and the critical debates that this last supper of female genitalia purportedly generated. The mission of "Sexual Politics" is to reconcile the *Dinner Party*'s popularity with its "almost automatic dismissal by Modernists, postmodernists,

and many feminists alike." (Make that *most* feminists.) This mission, however, is premised on two fairly serious misunderstandings. Firstly, Chicago's importance as a public figure is confounded with her importance as an artist, and as a consequence popular interest is confused with passionate commitment; Judy Chicago has apologists, sure, but few true advocates. Secondly, the *Dinner Party* is taken for "an important catalyst of critical debate," when actually it was just an easy target for critics whose debates were already underway. And it was a *fair* target to have been singled out when it was first exhibited in 1979, since even then it was blatantly anachronistic, acquired immediate and unctuous institutional support, brought enormous fame and money to Chicago, and was produced by vile means—Chicago exploited many unpaid and unacknowledged assistants under the guise of sisterhood. (I really hate it when that happens.)

As unwilling as the curator is to "either celebrate or condemn" the *Dinner Party*, she doesn't hesitate to impute the motives of those who have been willing to take a stand against it. According to Jones, critics of the *Dinner Party* are all "elitists," either unable to deal with its seductive "specularity" or unable to distinguish kitsch, as defined by Clement Greenberg, from Chicago's "didactically and decoratively accessible populism." Leaving aside the fact that Greenberg's commentary on kitsch is less a definition than the expression of a derisive attitude toward the academicized artifacts of popular culture, the fact remains that the *Dinner Party* is kitsch, nothing more and nothing other, a blatant, popular artifact rendered ludicrous by its higher aspirations.

This much would be apparent even to the blind if they had the mitigated pleasure, as I did, of listening to the *Dinner*

Party's audio guide. It features Chicago's gravely solemn, but flatly plaintive voice—Leonard Nimoy narrating *In Search of Ancient Mysteries* in the voice of a *Saturday Night Live* Whiner—reciting the kind of womanized Bible-babble that is inscribed on the tapestry banners that introduce the piece (see quotation on page 84), and further illuminating the iconographic "complexities" of this simplistic object's clichés. One learns that even the *Dinner Party*'s careless infelicities have deep symbolic significance: Can't read the hieroglyphs on the Hatshepsut place-setting? You could if you weren't "an uptight Egyptologist." Can't see the back portions of the runners (to which Chicago's assistants devoted hundreds of hours)? That was *intentional*, a metaphor "for the difficulty this culture has in seeing and understanding women's experience clearly." You find that the unadorned flatware and chalices contrast strangely with the decorative plates and runners? Yep, a metaphor "for the tension between women and their environment." Less generosity is required for the guided tour of the Nile that flows through the lobby of the Luxor casino in Las Vegas.

Ironically, were the *Dinner Party* presented for what it is, it might be redeemed, even warmly embraced. As ardent kitsch, I suspect, we could all get behind it. And why not? We embrace the films of Ed Wood, and his *Glen or Glenda* sexual politics, don't we? But would we love Ed Wood if we were asked to accept his centrality to the sexual politics of the history of cinema? Would we sit still for an exhibition organized around *Glen or Glenda* in an elite institution—with its storyboard, outtakes, and early versions artfully displayed, and its relationship to precursors and followers carefully analyzed by academics who conclude that the film's historical consequences turn out to be identical to Ed Wood's and his publicists'

87

grandiose intentions? And what if this Ed Wood spectacular were contextualized by the minor works of Ingmar Bergman, Roman Polanski, Yvonne Rainer, François Truffaut, Jane Campion, and assorted B-movies, each film selected to demonstrate but one aspect of the multifaceted Wood? If you can bite down on this, you're gonna love "Sexual Politics."

The six galleries that are devoted to contextualizing Chicago's work are filled with feminist art segregated into strenuously imposed categories, each gallery replete with voluminous didactic panels and object notes (lest the logic of organization be lost). Among the pieces selected for this exercise in intellectual illustration are a few undeniable gems, but for the most part what we find ourselves looking at, when we aren't reading, are minor works by major artists, along with works from the nineteen seventies and eighties that you thought you'd never see again—and one or two from the nineties you probably won't. Chicago prevails over them all: Here we discover the first occurrence of Chicago's "pulsating star motif, later used in the Natalie Barney place setting," there she "works through her relationship to Virginia Woolf," over here Chicago "makes a transition to highly developed metaphoric forms," over there she "uses the text-image techniques of the nineteen eighties." And everywhere she "attempts to confront the domain of high art, the province of men," and brings to the surface "hidden anxieties . . . by transgressing the Modernist value system . . . and threatening Western aesthetic conventions." Indeed, according to the curator it was the powerful effects of Chicago's "activated kitsch" that seduced the critic Hilton Kramer into revealing his elitism—as if Hilton Kramer ever tried to hide it. In any case, we are encouraged to "imagine the source of Kramer's anxiety as he contemplated the

sickly-sweet, pastry-like lace lips of the Emily Dickinson plate, which beckoned him unabashedly."

By this logic, of course, we might just as easily imagine John Ruskin losing his composure before the vulvar doors of Amiens Cathedral, since throughout "Sexual Politics" we are asked to accept similarly speculative accounts, not only regarding the psychology of beholders' responses, but of artists' intentions. And at no point is any distinction drawn between literal symbolism and embodied representation—between the iconography of sex and the viscerality of sexiness. As a consequence, in the area of contemporary vulvar representations, the critical distinction between Judy Chicago's bombastic symbolism and Judie Bamber's exquisitely embodied allure—available to the least sophisticated viewer—simply disappears, and all the pro-pleasure rhetoric in the catalogue comes off as only words.

In any case, a taste for the literal (i.e., the suppression of embodied meaning and the celebration of blatant signifiers) pervades the exhibition. Lynda Benglis's 1974 *Artforum* advertisement, in which she is naked and sports an "interventionist" dildo, is included, but not a single example of her anti-formalist, anti-Greenbergian abstract pour-pieces—in fact, there's no actual work of *art* by Benglis at all. Moreover, the objects that purport to constitute Judy Chicago's "context" are found in pretty strange contexts themselves: A lonely Cindy Sherman "film still," which only incidentally features a sultry hausfrau, shows up in the gallery devoted to "Politicizing the Domestic Sphere." Eleanor Antin's solitary contribution, a photographic memento of her faux life as a black ballerina, shares company with artifacts by women of color and lesbians in the "Multiplicity" room, where it is credited with having introduced to feminist art the idea of ethnic diversity. Thus 89

Antin—described as a "white, middle-class, heterosexually identified" artist—rather than being credited with transforming traditional ideas of selfhood, is unnecessarily rescued from political incorrectness.

Given that one of the goals of "Sexual Politics" is to correct the "widespread" misconception (in truth, held by few) that Chicago's oeuvre is representative of feminist art production in the nineteen seventies, the inclusion of just one misplaced work by Antin is strange in itself, since the elision of the rest of this artist's groundbreaking career—which problematized the *Dinner Party* before it was even conceived—defeats this very goal. Making the task even more difficult, the exhibition elides the signature works of Hannah Wilke and Carolee Schneemann, and thereby a great deal of the impudence and effrontery with which so many first-generation feminists employed the nonabject, full-figure female nude to feminist ends. While this strategy may have the desired effect of frustrating masculinist desire, it serves primarily to reinforce the supposed predominance of Chicago's clumsily transcendental brand of puritan sexuality. The large supporting cast of vulvar icons and other forms of bracingly joyless sexual sanctimony merely cements this idea, while similarly selective surgeries on art of the nineteen nineties incorrectly assert that Chicago has influence on—and important followers in—the new generation.

In fact, Antin and Wilke, who should have been among the stars of this "contextualizing" production, seem to have received their minor roles only because the sexual politics in their works is easy to spot. Others are not so fortunate. How does one explain the exclusion of the whole ebullient context of feminist art in Los Angeles in the nineteen seven-

ties? Miriam Schapiro and Mary Beth Edelson declined the invitation to sing in Chicago's choir (along with New York artists Joan Snyder, Nancy Spero, and Joyce Kozloff), but other high-profile artists like Alexis Smith and Vija Celmins (who formed their own consciousness-raising group as an alternative to Judy Chicago's), Karen Carson (who participated in Chicago's group), and Judy Fiskin (who directed L.A.'s Womanspace in 1973), weren't even asked. Big mistake. One would think that a poststructuralist such as curator Jones, who is able to detect the "virility in formalist grids and stripes," might have been able to detect the sexual politics in the work of these feminists. And surely Chicago's relationship to these women is at least as important as her relationship to L.A.'s Finish Fetish men—and equally as deserving of an essay in the catalogue.

But thank goodness for Laura Meyer's catalogue essay on Chicago's early years, when her feminist heat flamed in the face of the "cool school's" cool, for in it she observes (albeit hidden in the tiny print of her final footnote) that the *Dinner Party* is moralistic, not obscene, and that "it has a didactic, preachy quality that can seem quite overbearing." Too bad Meyer didn't begin with this thought, since it might have led her to the full implications of what it means to be cool. Any kind of history, however, is welcome relief from the ahistoricism that pervades "Sexual Politics." This exhibition leads one to believe that styles, forms, and materials once gendered remain forever so, and that the same Greenbergian formalism that Chicago "exploded" in 1979 (in the wake of Pop artists having definitively exploded it by 1963) must be exploded again in 1996— along with other forms of patriarchal Modernism now totally defunct. As a consequence, "Sexual Politics" presents a num-

91

ber of recent works that apparently have the intention of carrying on the campaign. (One thinks here of Civil War buffs, reënacting the Battle of Gettysburg in some pasture.)

According to the wall labels, the tactics of nineteennineties feminists include redeeming oil painting as a feminist practice, playing off frivolous decorative crafts like needlepoint against the masculine structure of modern formalist painting, decoding formalist structures with menstrual blood, challenging idealized constructions of motherhood, intervening in artworld discourse that heroicizes male artists and objectifies women, and the (tried and true) deconstructing of Édouard Manet's *Olympia*. If these are indeed appropriate strategies for the new generation, then the anxiety of influence must be, as Harold Bloom would have us believe, an exclusively masculine phenomenon. Otherwise, we must presume that all of the transgressing, intervening, decoding, disrupting, and deconstructing of the first two generations of feminists was for naught.

At risk of being perceived as an uptight Egyptologist, I must observe that the critical art history proposed in "Sexual Politics" is neither critical nor historical. Instead, it is a kind of medieval typology—a static and theoretical conception of "history" that constructs a virtuous feminism in eternal struggle with a Modernist, patriarchal Satan; to *judge* art by feminists is simply to be possessed by evil ideologies. How did "Sexual Politics" end up in the Middle Ages? Not by transgressing patriarchal rules, but by ignoring the standard rules of critical practice. Despite the curator's stated intention to contextualize Chicago, she routinely commits the primary, dehistoricizing sin against contextualization by assuming that the meaning and social value of a work of art may be assessed

according to the declared or otherwise constructed intentions of the author. As w.к.Wimsatt and Monroe Beardsley argued in their canonical essay of 1946, "The Intentional Fallacy," the work of art must be measured against context, against the efficacy of the work of art at some particular historical moment. For most, this principle is an axiomatic, even primitive aspect of descriptive criticism in all fields of cultural analysis. If art criticism had laws, avoidance of the intentional fallacy would surely be one of them. Yet, in one fell swoop of an exhibition, feminist art is exempted from social context—a disastrous mistake, given feminist art's manifest, ongoing, and dramatic art-historical and social consequences.

In lieu of social consequences, "Sexual Politics" is but a litany of artistic intentions, sometimes emanating from the artists themselves, but more often than not constructed for them out of the idealist realm of theory. The exhibition asks us to believe that feminist themes constitute feminist strategies— that theoretical intentions constitute, prima facie, effective political actions. One may wish that this insistent commission of the intentional fallacy were an aberrant case of curatorial naïveté, but the tendency among third-generation poststructuralist art critics and historians to confound the conceptual implications of a work of art with the artist's concept of the work—to disregard its mutable, historical public life—is all too common. Disregard for context, of course, constructs the relationship between art and its audience as dominant and subordinate. With audience response thus policed, the political onus is removed from the object. Art need not perform; it need only signify its *wish* to perform. Unfairly, then, "Sexual Politics" presents feminist art as a refuge from the risky world outside— a safe "woman house," an exclusive cult of sisterhood in which

93

no one wins and no one loses, and everyone means well.

In this cosmology, feminist art is a progressive, internally evolving autotelic collective in which feminists endlessly reënact past battles with patriarchy (ignoring the present ones), and perpetually rewrite the "Woman Bible" in an effort to achieve absolute subjective grace. If the ticket for admission to Clement Greenberg's similarly structured formalist club was self-evident "flatness," the ticket into this one is superficial sexual politics. Presently, however, this model of understanding art is suffering the same moral decay and theoretical entropy that in the nineteen sixties put Greenbergian formalism out of business.

For the feminist cosmology that "Sexual Politics" presents, the writing is on the wall, and no barrage of wall notes, banners, audio guides, or weighty catalogues can police the contemporary audience's response or restore the vigor of a failing discourse. Because, ironically enough, "Sexual Politics" is exactly as old-fashioned in 1996 as the *Dinner Party* was in 1979, demonstrating once again how suffocating ideological sisterhood can be. Feminist art cannot be expected to survive as an ahistorical cloistered practice which cannot fail, seemingly never succeeds, and consequently never changes. If feminist art is removed from the contingencies of social life, its role in the larger project of feminist activism is lost. Lo!

Hello Daddy, Hello Mom,

I'm your

ch-

ch-

ch-

ch-

ch-

ch- cherry BOMB.

●

JOAN JETT

AND

KIM FOWLIE

Bad Girls

"Bad Girls West," at the Frederick S. Wight Gallery on the UCLA campus (January 25–March 20, 1994), purports to introduce a new wave of unruly women's art. (Actually, it purports to introduce only *part* of the wave: sixty-three of the total 106 artists are represented in this West Coast venue, with another grouping in its sister exhibition "Bad Girls" at the New Museum in New York City.) Despite the tsunami size of this wave, few of the sculptures, paintings, photographs, videos, and installations embody the kind of libertine subversion implied by the title, being neither particularly "bad" or demonstrably "girlish." And that's too bad, because the time for bad girl art surely has come.

In the catalogue and small 'zine that accompany the exhibitions, curators Marcia Tucker (East Coast) and Marcia Tanner (West Coast) tell us that bad girl art is art by women (and a few "good" men) that manifests a new spirit, distinct from that of the feminist art of the nineteen seventies and eighties. The new feminist art, they say, is characterized by an affinity to the carnival and early burlesque; it exploits the grotesque body, inversion of power positions, and deliberately excessive and raucous humor, all in service of a scathing critique of cultural expectations of femininity.

Humorous attacks on cultural constructions of femininity, however, are nothing new, and, in truth, most of the works are more overripe than fresh: high heels fashioned out

97

of sponges and scrub brushes (who wears high heels any more?), deconstructions of (presumably masculine) Minimalist sculpture (which is no longer part of the *Zeitgeist*), and lots of somatic objects decorated with hair or fur (but none with the shocking originality of Meret Oppenheim's surrealist *Luncheon in Fur* of 1936). There are exuberant assertions of lesbianism and aging, but, for the most part, the works that aren't deathly joyless are merely silly, and few come close to the complex, anxious humor of works by nineteen-seventies pioneers Hannah Wilke or Eleanor Antin, or the film stills and fashion shots of Cindy Sherman from the early nineteen eighties, which are funny indeed.

There are bright moments, as one would expect of any survey of women's art this wide: Jeanne Dunning's photographs of greatly enlarged, slightly out-of-focus navels (at least I think they're navels) force one to admit to uncontrollable fascination with any bodily orifice, and her flat, square, flesh-colored latex sculptures, each about 16-inches on a side and punctuated with a single flaw—a hairy wart, a cluster of pimples, a red sore— cleverly finish the project of desublimation begun by Eva Hesse. Elizabeth Berdann's miniature portraits of her own "thirty worst features"—varicose veins, cellulite, mustache hairs, and such—are painted with almost perfect verisimilitude and in a laborious old-master technique that, in our present culture, embodies the idea of obsession. And in gestural paintings of violent little girls, Kim Dingle avoids the pitfall of illustrating Freudian theory that Eric Fischl once fell into, and into which many in this exhibition fling themselves with full force.

However, none of these standouts or the half-dozen or so other gems that make the show worth seeing deliver on the promise of bad girl art, defined in one place in the catalogue

as art that is anti-ideological, nondoctrinaire, nondidactic, and unpolemical, and in another as rebellion against the ideal of femininity constructed by Hollywood and the popular media. What they do deliver is the message that mainstream feminist ideology, doctrine, didacticism, and polemics have been frozen in opposition to the ideal of femininity constructed by Hollywood and the popular media for too many years, and thoroughly naturalized in institutional culture; none of the works presented tread on any feminist toes. Not surprisingly, then, the only controversy this exhibition stirred centered on its title.

According to the curators, the slogan "Bad Girls" was chosen in order to usurp exclusive claim to the role of *enfant terrible* from male artists who have profited from its purported aura of creativity. Despite the dubious advantage of perpetuating this Modernist myth of testosterone-driven inspiration and behavior, and despite feminists' many objections to the infantilization implied by the word "girl," the problem with this exhibition is not in the name given it; that was the part they got right. As curator Tucker points out, the terms "bad" and "girl" have been redeemed in African-American vernacular and disseminated in the broader culture. Indeed, one would welcome the opportunity to see new art by women that transgressed both the expectations of bourgeois politesse (bad art) and the proprieties of mainstream feminism (girl art). But what we see here is the already down and beaten nineteen-fifties feminine ideal, uncontroversially beaten up some more.

The problem with this exhibition would seem to rest with the curators' failure to see that the good girl against which a bad girl might rebel is no longer constituted by the Hollywood model, but by the puritan paradigm constructed by aca-

demic feminism itself. Thus, the artists in this exhibition come off less as bad girls than as good, party-line feminists; the works consistently speak from virtue rather than desire. Nowhere in this exhibition do we discover what a woman might *want*, only what she does not. The only news is the stale news of orthodox feminist iconoclasm. Marxist ideology and critiques of the masculine "gaze," of which Katherine McKinnon's anti-porn campaign is a belated manifestation, entrenched themselves in the late nineteen seventies and early eighties—a *long* time ago. The exhibition further suggests that the orthodox prohibition of images of women has been expanded to include any kind of image that women might want to see—any kind of object upon which a woman might project her desire. The logic is utopian: If nothing gets objectified, then nobody gets hurt.

But power isn't pretty, and the desire to be bad is bubbling up, if not in feminist art, seemingly everywhere else. Last week Roseanne got stoned, overate, and neglected her children without reprisal or remorse, and Tonya Harding, guilty or no, effectively shattered the image of the unambitious ice princess. (Harding's radically disconcerting construction of femininity comes much closer to illustrating the definition of the grotesque cited in the catalogue than the intrusion of a few pimples or warts on otherwise perfect skin.) The New York exhibition, then, wisely includes works of women in stand-up comedy and rock and roll—two genuine hot-beds of transgression—that generate the ambiance of badness that the West Coast version sorely lacks.

In fact, bad girlism has not been confined to popular culture. Although academia quickly marginalized the ravenous persona of Camille Paglia, Jane Gallop (who has authored canonical feminist texts) is not so easily dismissed. Gallop

advocates a pedagogical technique that recognizes the connection between seduction and pedagogy and, in the wake of charges of sexual harassment, even joked that her "sexual preference is graduate students." (Now *that's* bad.) If the artists in the West Coast show can be said to be bad, they are bad only in the way Lorena Bobbitt was momentarily bad, a good-girl victim driven to angry retaliation. A sad tale of victimhood, or an angry wagging finger, occupies every corner of the gallery's tortured chambers, and the raucous pleasures of burlesque are nowhere to be found.

Nevertheless, to conclude that the virtuous spirit of communitarian sisterhood must have guided the curator's selection process would be a mistake; it is not as if the right bad artists were overlooked. This exhibition is a fair representation of what's out there by younger self-proclaimed feminist artists, minus, mercifully, the multitude of eco-goddesses automatically disqualified for theatricalizing their goodness in more explicit ways. The size of this feminist wave, however, is suspiciously large, over a hundred artists in total. Conventional wisdom suggests that any number over, say, fifteen is not a new wave, but the splash of the last.

Thus, what feminist art needs now are a few good—or bad—mothers of invention. If showing us what women want creates a schism in the Movement, so be it. Would we, after all, be fighting over something holy? Feminism as a practice, I suspect, would be better for it, and we might learn how a few bad girl iconophiles envision their desire.

Generals
KILL *their*
thousands,

Saints
their
hundreds of thousands.

●

OSCAR WILDE

Virtue Be Damned!

Throughout the nineteen fifties and six-
ties, Lyndon Baines Johnson's burgeoning political career kept
him very busy. He spent most of his time in Washington, D.C.,
but always managed to be at his favorite home, the LBJ Ranch,
in April. He enjoyed the early warmth and the fields of blue-
bonnets that transform the pastures of central Texas's Hill
Country (where the ranch is now a tourist attraction) into spec-
tacular rippling waves of azure blossoms. On sunny days, he
would put the top down on his convertible Cadillac, slam
through the low-water crossing on his ranch road—laughing
with mischievous delight as the splash showered captive
guests—and head out onto the blacktop for high-speed tours
of the countryside. Not infrequently during these romps, I've
been told, he would kick back a beer, then toss the empty can
straight in the air, leaving it to bounce to a rest on the road
behind him. (Folks littered back then.)

Not to worry. Lady Bird Johnson soon came along
with her Natural Beauty campaign to tidy up after Lyndon and
his generation. Her campaign turned out to be one of the most
successful public-interest drives in history, its crowning
achievement being the Highway Beautification Act of 1965.
Inspiration for the campaign had come in part from Lady Bird's
predecessor, Jacqueline Kennedy, whose more modest (and
elitist) project had been the restoration and embellishment of
the interior of the White House. Lady Bird, a true democrat,

took Jacqueline's idea out-of-doors, and in so doing, transformed the visual environment of nearly the whole of quotidian America. Across the nation, trees and shrubs usurped the traditional bronze plaque in public plazas, and parks brightened the gloom of inner cities. Lady Bird's program for sprucing up highways—litter prevention, relocation of unsightly junkyards and power lines, seeding of wildflowers along rights-of-way, and (tragically, in my own minority opinion) removal of billboards—brought unrestricted views of the natural sublime to almost every member of the Great Society. She soon broadened the parameters of the campaign to include air and water pollution reforms, thus foreshadowing the environmental movements that began in the late nineteen sixties. If eco-feminists deigned to celebrate real-life heroines, Lady Bird surely would be proclaimed Earth Goddess incarnate.

*

This vignette of Johnsoniana looms large in my ethnic past. It embodies in high contrast a stereotypical—some say intrinsic—difference between the sexes: Lyndon the corrupt politician, Vietnam War monger, and quintessence of ruthless patriarchy; Lady Bird the nature lover, nurturer, and vessel of feminine virtue. Nevertheless, for myself and the small band of Texan feminists with whom I consorted in the early nineteen seventies, the choice was obvious: To hell with virtue. We drank beer and roved in old Cadillacs. (Mothers Against Drunk Drivers had not yet waged their successful campaign.) Cruising the idyllic fields of wildflowers along Interstate 20, we tipped our baseball caps to Miss Lady Bird, as we called her, and tossed our empties in the back seat. We actually respected Lady Bird and forgave her her anachronistic values, in the way one must forgive the best of a dying breed, but we aspired to

Lyndon's confidence and authority. Back then, feminism was exciting and sexy; it promised the joy of power and privilege, the right to be exuberant, naughty, and self-indulgent—to be not only our best selves, but our worst selves, and in public.

At some point along the way, that promise was withdrawn by mainstream feminism. Despite Mary Wollstonecraft's late eighteenth-century warning about the perilous consequences of mythologizing feminine virtue, institutional feminism today wallows in the quagmire of this very myth. If feminism managed to break the age-old connection between chastity and virtue, it found new femininities no less chaste. Wollstonecraft had been responding to the eighteenth-century proclivity that only intensified in the nineteenth century, to enshrine woman as the repository of familial virtue. With woman ensconced as "queen of the house," men were liberated to respond with ruthless expedience to the necessities of mercantile and political interaction. Women were free only to provide their families' expected quotient of undefiled and uncompromised virtue. Institutional feminism has taken it one step further by positing woman as the repository for the ethics of all humanity and by constructing femininity as essentially self-effacing, nonaggressive, and nurturing. These conceptualizations implicitly promise that if feminism prevails, then the "feminine vessel"—overflowing with its store of goodness—will spill forth to salve all wounds.

Such constructions, however, merely reconstitute those eighteenth- and nineteenth-century male fantasies of essential femininity; patriarchy, of course, is happy with *any* construction of the feminine that keeps women out of its business. Furthermore, radical feminist theories, as trenchant and enlightening as they often are, have the tenor of a quest for redemp- 105

tion, not liberty. Indeed, the idea of virtue as the province of the feminine is the single thread that unites—and ultimately will unravel—virtually all of today's disparate feminisms.

Mercifully, the comical discovery of a natural, nurturing, peaceable "goddess within" (parodied so acerbically in Francine Prose's book *Hunters and Gatherers*) has been discredited in the higher realms of institutional feminism. Nevertheless, our same community has discovered feminine virtue in places no less unlikely. Certain poststructuralist feminists propose that virtue develops in early childhood, when the feminine is excluded from the (implicitly evil) realm of the symbolic. Some feminists, who ground their theories in Freudian psychoanalysis, believe the lingering bond between mother and daughter has a residual positive effect throughout adulthood, creating a female propensity toward a (supposedly) virtuous communitarianism, manifest in the purportedly caring behavior of pre-adolescent girls. According to certain Marxists and Lacanians, this virtue continues to reside latent in the hearts of female victims of internalized ideology; it waits there to be freed by de-commodification or by the selective censorship of patriarchal images and texts. Remarkably, evidence of essential feminine virtue has been discovered even by many feminists who purport to have forged their theories solely on the anvil of personal experience.

Feminism, however, shall surely fail if it remains grounded in the myth of feminine virtue. Already the effect on the cause of women's liberty has been devastating. We have reduced discussions of power and privilege to discussions of sex and psyche—a feminist inversion of the Surrealist revolution that is destined to meet a similar fate. For the most part, power and privilege are reified as unredeemable evils. On those rare

occasions when secular power is celebrated by feminists, it invariably has been confused with anger, vengeance, or proprietary indignation, or constructed as a warm and fuzzy concept of absolute equality or fairness. And despite the mounting criticism of institutional feminism's practices and presumptions that emanates from the very social sciences in which many of these feminist theories were first formulated, the goal of power in dominant feminist discourse continues to be supplanted by the implicit promise of a feminist utopia presided over by enlightened, if no less proprietary, Lady Birds. In place of exploitation will be nurture; in place of hierarchy, equanimity; in place of contractual relations, communitarian ethics. There will be love-making, but no loveless sex; desire, but no gazing at it.

Thus, virtue has emerged as the *rationale* for feminism. In turn, radical feminism's success has become contingent on the success of a feminist utopia and must defer coming to terms with power as it awaits the dawn of universal equanimity—which, of course, never comes. Feminism needs no rationale. At least, it need look no further than the abstract principles of life, liberty, and the pursuit of happiness. After all, equality (which feminist discourse has transformed into a rather squishy, metaphysical concept) exists only in law, not in nature. Indeed, it is precisely the inequalities in nature that law seeks to mitigate.

What must feminists do? We must damn virtue! How? We begin symbolically: We banish anthologies and special issues of journals devoted to "Women and Peace," "Women and Ecology," "Women and Specieism," and the like. Although peace, environmental protection, and animal rights unquestionably are good for the world, the tendency to treat these

issues as the special province of women is unquestionably bad for feminism. After all, feminism ultimately may prove not to be good for the world; it may prove to be good only for women.

It may seem peculiar to want to damn virtue, since in almost all philosophies virtue is the object of cultivation. But just as gentility, nobility, and communitarian ethics are the perks, not the causes, of cultural privilege and prosperity, certainly pure virtue is a symptom, not the source, of exclusion from power and the necessities of mercantile and political participation. The question feminist theorists now must address is whether or not putative feminine virtues are indeed virtues, keeping in mind that making women's rights contingent on women's goodness is suicidal for the Movement.

The disastrous consequences of virtue-based, puritanical feminism have been nowhere more apparent than in the visual arts. The major feminist exhibitions of the mid nineteen nineties—"Bad Girls" and "Sexual Politics"—were organized according to the imperative of communitarian ethics as opposed to the imperative of critical discernment. As a consequence, these exhibitions, for the most part, featured new works that merely illustrate obsolete feminist themes and excluded important new work by women artists who fearlessly ignore the proscriptions of academic feminism, and in every other way demonstrate real artistic power. It remains to be seen whether the manifest collapse of the inconsequential feminist-themed art that "Bad Girls" and "Sexual Politics" presented to public view will be taken for the collapse of feminism itself. In any efficacious feminist philosophy, there are no good girls and bad girls, only women. Virtue is, as Wollstonecraft so clearly described it, "artificial behavior, encrusting morality [and] specious poison."

Feminism is not a moral philosophy, and in institutional feminism's effort to make it one, the movement has been invested with the proprieties of a holy crusade and robbed of the reckless joys of secular political rebellion. Feminism must concern itself only with the acquisition of power for women, and acknowledge the fact that the construction of good womanhood is every woman's individual right, not her precondition for full citizenship. Feminists must shun what Jane Jacobs has called "guardian culture," with its moral syndromes of obedience, exclusivity, and vengeance, in favor of her concept of "mercantile culture," with its valorization of dissent, collaboration, and competition. We must trade the purported safety of communitarianism for the risks inherent in contractual relations. In short, we must invade the secular world in full force and be willing to discover, after the fact, how that world is changed by our presence. We must embrace the responsibility of power and the exigencies of acquiring it—and forgive ourselves if, after millenniums of oppression, we fall victim at last to its privileges. Forget idealized notions of equality. Feminists must want to win, or women will lose with their virtue intact.

"Think,"

we might imagine Colbert
explaining to the academicians,
"for the king orders it; your
reflections will
reflect his majesty and
his grandeur". . .

Colbert
asked them to reflect
the king's glory
and at the same time offered
them a way to work on their
own reputations—

since royal power,
like the sun,
necessarily fell back on those
who reflected it.

●

JACQUELINE

LICHTENSTEIN

The Redemption of Practice

Artists are making things again. In the mid nineteen eighties, a few scattered revisionists began receiving attention for crafting instead of shopping, inventing rather than appropriating, and generally rethinking the whole concept of conceptual art. By the late eighties, works asserting their materiality had trickled into galleries on the coasts, and now, everywhere you look, there are objects that come in substances, colors, shapes, and sizes that matter. The near thirty-year hegemony of art constructed solely as a liberal art—as an art of the mind—has come to an end. Not coincidentally, art critics, historians, and theorists have begun fretting over a vague and ill-defined crisis in their discipline. In fact, they are faced with what appears to be a daunting, full-scale redemption of the idea of art as a practice.

Liberal-arts academicians appear to be having a particularly rough time with this sea change. The critical theories upon which they would rely, formulated between the late nineteen sixties and early nineteen eighties in empathy with the conceptualist styles that inspired them, are useless when addressing works that radically blur the distinction between materiality and thought. The solutions that have been proposed have the ill-effect of replacing the study of art with the study of "vision": to rely more heavily on (often unexamined or locally discredited) theories developed in other fields; to establish interdisciplinary credentials through the acquisition of

advanced degrees in psychoanalysis; or to simply, in the words of one eminent art theorist, "further examine early childhood development." Plainly, these strategies merely exacerbate the problem by further isolating theory from practice. In fairness, it must be admitted that in the long history of theories of art, no theory has *ever* effectively reconciled the idea of art as a practice with the idea of art as a liberal art.

From the moment the idea of the liberal arts was conceived in antiquity, to distinguish the arts of the mind from the arts in the world, controversy has arisen in various forms: arguments over the relative priority of rhetoric and philosophy in cultural production; over the relative virtues of commercial interest and academic disinterest among artists and critics; over the relative importance of materiality and concept in the experience of works of art; and over the relative priority of color and drawing in artistic practice. Today, these arguments have resolved themselves into one general dispute between theorists who concern themselves with the manifest social consequences of the physical work of art, and those who concern themselves with the causes of artistic production.

Present-day academicians, of course, concern themselves exclusively with the latter. So deeply are they invested in the construction of art as philosophy that they have dispensed with the bulk of the language once used to describe material objects. Despite the fact that art must, by definition, embody its meaning, the term "form" is censored or disparaged. The priority of concept is so taken for granted in the fine arts (to the denigration of practice) that the term "design," historically associated with the artist's idea, and lately associated with the product of practice, has been relegated exclusively to the realm of the "commercial" arts where, presumably, consequences still

112

matter. For years, the logical inconsistencies of academic theories were cloaked by an ever-thickening forest of works in conceptualist styles, creating the illusion that these works of art are in no need of physical address. With the growing popularity of styles that assert art's physicality, academicians, out of habit or necessity, have had to struggle to protect their turf.

Consequently, we find ourselves on the brink of reënacting the farcical controversy that took place between the Poussinists and the Rubenists in late seventeenth-century France. As Jacqueline Lichtenstein reminds us in her subversive book, *The Eloquence of Color: Rhetoric and Painting in the French Classical Age*, the authority of the French Academy and, in turn, the authority of its king were at stake in the seemingly trivial quarrel over the priority of drawing and color. Jean-Baptiste Colbert, acting on behalf of Louis XIV like some outsized art-school dean, ordered the academicians to demonstrate art's relationship to philosophy. In effect, he commanded his appointees to think and paint philosophically, in order to legitimize the art that legitimized Louis's régime.

Rather than demonstrate intelligent thinking—by producing compelling new designs in art—the king's Poussinists resorted to legislating the priority of "drawing" as the *signifier* for thought, thus affirming the discursive ascendancy of drawing over "cosmetic" color. Hence the present, pervasive sense of déjà vu. Just as the Poussinists found themselves in the unattractive position of defending the idea that the ethical value of painting resides in a particular form (the seemingly cerebral, linear tradition), today's academicians defend the ethical value of a colorless, disembodied conceptualist idiom: The 1997 Documenta exhibition is one example, the recent effort by academicians to transform the discipline of art studies into 113

"visual studies" another.

The drawing-versus-color debates between the conservative Poussinists and the insurgent Rubenists were, at heart, reënactments of the original Greek academy's argument over the primacy of philosophy and rhetoric. The ancient classical world excluded the arts of practice from the academy on social grounds: The liberal arts (the arts of the mind) were suitable for free-born or "liberal" citizens, while the vulgar arts (the arts of practice) were relegated to low-born tradespeople, slaves, and foreigners. Philosophers were permitted to speculate on the nature of the arts, but they were expected not to practice them. Aristotle, for example, accepted music into the academy, but with the proviso that the academician should avoid the vulgarity of virtuoso performance—physical virtuosity being the practice of serfs and slaves. High-born citizens, he insisted, should concern themselves only with occupations of the mind.

The radical idea that the *practice* of painting should be a liberal art—a philosophical endeavor—began innocently enough in fifteenth-century Italy, when Leon Battista Alberti urged artists to become humanist intellectuals as an aid to better practice. In the sixteenth century, however, Giorgio Vasari and other Italian theorists transformed the sanguine notion that art might benefit from the thinking artist into the idea that mindful art is manifest in a particular *style*. Although their debates were posed as a defense of art's liberal status, they most often were staged as a defense of the Tuscan linear conceptualists (Leonardo, Michelangelo, Raphael) against the hedonistic colorists of Venice (Giorgione and Titian).

Although the Italian theorists managed to effectively deliver art from the realm of craft and trade, they fell short of

114

theoretically legitimizing practice per se, since they divided art into redeemable "good" practice and unredeemable "bad" practice. At the root of this theoretical shortcoming is a fundamental logical flaw that characterized almost all Renaissance theories of art, and subsequently almost all of the ones that followed: The art object was conceptualized as a circumstance of mind. As soon as the term "design" entered the newly developing art vocabulary (to designate preliminary drawing), it came to mean the creative idea behind the finished work. In this way, the thinking artist was distinguished from the ordinary craftsperson, and the ancient distinction between mind and practice was recast as an hierarchical distinction between fine art and craft.

Soon thereafter, the idea of design acquired a mystique, due to the often-drawn analogy between the creative activities of the artist and the creation of the world by God or by a Platonic demiurge. Although the notion that the artist is divinely gifted with the "power to design" may have contributed to the social elevation of the visual arts, it preëmpted the need to construct the kind of theory needed to address the contingencies of practice—a theory that might have properly accounted for the ardent constituencies that accrued around the spectacular objects being produced by superstar Renaissance artists. In retreat from the challenge of constructing a theory of liberal-arts practice, Renaissance art theorists constructed the art object as a microcosm of the Christian universe, finding in it evidence of the artist's plan in precisely the way that theologians (in what is called the "design argument") had found evidence in the world of a universe evolving according to God's grand design. In the Renaissance scheme, the value of the art object is theoretically predetermined by its

divinity, and its design is analyzed exclusively as a construction of the artist's intentions for it.

At its inception, then, art theory became deeply implicated in what is known as the "intentional fallacy"—the assumption that the meaning and social value of a work of art may be judged against the authors' declared intentions, or by the intentions constructed for the author by a critic. Subsequently, in the discourses of seventeenth-century Platonists, eighteenth-century rationalists, and the Romantics and Symbolists of the nineteenth century, commission of this fallacy was standard practice. At the very end of the nineteenth century, early formalists transformed individual intentionality into comprehensive organizing principles; Heinrich Wölfflin's *zeitgeist* and Alois Riegl's *kunstwollen*, which posit art as the effect of a culture's spirit or will, merely replaced God and the author with history and culture. Despite the widely accepted illusion that so-called postmodernist theories of art obviate the possibility of intentionality by removing the authority of the author and constructing the object as an effect of culture, contemporary academic theories merely follow suit.

Indeed, were postmodern academicians to reëxamine their theories (rather than liturgically reiterating them), they would see that they merely are reconfiguring the formalist theories that their own theories are meant to oppose. The idea of the death of the author, after all, originated long before the linguistic turn, *pace* Wölfflin's "art history with no names." Wölfflin and Riegl, however, were unconcerned with correcting the logical inconsistencies in Renaissance-Romantic constructions of intentionality. (The idea of individual creative genius remains a vital aspect of critical practice well into the twentieth century.) Instead, they were responding to the con-

sequences of the industrial revolution and, more importantly, to the threat these consequences posed to the liberal-arts status of their endeavors. At the end of the nineteenth century, this entailed distinguishing pre-industrial craft objects—the "authorless" textiles, pots, and such that were often the object of their studies—from industrial, commercial objects, which were not. Indeed, the source of present-day confusion lies in the willfully illogical ways in which art theorists continue to struggle to maintain the distinction between the liberal arts and the arts of commerce, and to deny that the ultimate validation of art takes place in the social economy.

The urgency to distinguish art as a product of mind was intensified and theatricalized by the proliferation of industrial objects in the nineteenth century. Industry itself seemed to validate the ancient distinction between the liberal and the vulgar arts, since it institutionalized the divorce of design from production, a separation that was anathema to Romantic fine-art practice. With the arrival of the machine-manufactured object (and subsequently photography), an inversion took place. The designed object in its entirety no longer signified the artist's intention: Whereas in seventeenth-century France the artist's touch had signified rhetorical materiality, in nineteenth-century France and England it came to signify mind or intention, asserting the primacy of the fine-art object over the industrial object, a hierarchy that asserted the ethical value of the fine arts through the association of Romantic constructions of individual creativity with the divine.

This hierarchy was exploited and given added weight by those nineteenth-century theories that inspired and fueled the Arts and Crafts Movement. Such theories proposed a hierarchy of form based on the lifestyle or culture of the form's 117

maker. The contingency associated with Gothic decoration was redeemed by virtue of the supposed relative social freedom of the medieval craftsperson, and the idiomatic irregularity of the handmade object was elevated in esteem by the proclaimed virtues of the pre-industrial lifestyle of its maker. Thus, the Renaissance hierarchical distinction between art and craft was recast as a distinction between handmade craft and mechanized industry.

The early formalists, whose theories in essence redeem all types of designs equally (so long as these designs properly express their place in history and culture), simply ignored this logical implication by ignoring the contemporary world, thereby effectively distinguishing the fine arts, as well as fine crafts, from the arts of commerce. Any validation that the fundamental logic of their theories may have lent to industry did not extend to commerce, which necessarily must be a discourse of consequences rather than causes. This allowed twentieth-century formalists to maintain a distance between art and commerce while adapting formalist theory to the critique of contemporary art. Early twentieth-century aestheticists naturalized formalist theory by positing the idea of "significant form" (Clive Bell's term for art that provokes so-called aesthetic emotion) as a separate category. The ethical value of the aesthetic emotion occasioned by significant form would seem to depend upon its constitution as an order of feeling distinct from the desire felt for commercial objects.

Toward mid century, an expanding market for the fine arts forced art critic Clement Greenberg to extremes. His theory of a determinist history of painting—in which the medium itself exists in a realm wholly distinct from other objects in the world—is an autotelic construction of art in which painting's

purpose is its destiny. However peculiar and strained Greenberg's theories were, his variation on the formalist theme enabled him and his many followers to assert art's distance from the "vulgarity" of mercantile culture for well over twenty years—by attributing the obviously market-driven style changes in abstract painting to history, and the aesthetic "quality" in painting to its submission to destiny.

Soon after the mid twentieth century, however, the discrepancy between theory and reality—between the anti-mercantile ideology of high Modern art and its burgeoning commercial success—was exacerbated by a rise in anti-capitalist sentiment. Once the ethical conflict presented by America's corporate investment in both art and the corrupt Vietnam war destroyed the formalist screen behind which art's mercantile character had been hidden, the foundation upon which art's liberal status had rested since the Renaissance fell away. Art theorists were faced with a genuine dilemma: develop a secular theory of practice, or preserve the liberal-arts bias at the *expense* of practice.

Practicing artists of the time responded in two disparate ways: One school figuratively abolished practice by reallegorizing anti-mercantile sentiment within the purview of the dematerialized object (the various forms of conceptualist practice such as Minimalism, performance, and installation), while the other allegorized bourgeois desire and the idea of mercantilism itself (Pop). These styles were equally effective in deflating the overdetermined value formalists had assigned to material abstract practice. Art theorists, however, would respond in only one way. The theoretical discourse that followed the nineteen-sixties revolution has held true to the liberal-arts bias. Like their Poussinist ancestors, academic theorists have

119

attempted to legitimize the academy by making art studies more philosophical, by dematerializing the art object in theory and constructing it exclusively as evidence of culture's visuality: A hard construction of the object is sacrificed for a soft construction of vision. Vision, of course, is just another word for mind, will, *geist*, or material destiny. Indeed, it is a concept that encompasses the whole list.

Thus, we are forced to admit that postmodernist art theories constitute less of a radical rupture with their historical predecessors than a reallegorization of traditional premises and the most extreme manifestation of a tradition in which idea is given precedence over practice. They are the logical consequence of a long line of logical inconsistencies. For the mid-twentieth-century formalist, the design (and the meaning) of an object rested wholly inside the frame, which is the only place painting's complicity in mercantile economies might be denied. For the present-day *visualiste*, design (and meaning) reside wholly outside the object, which is the only place it can exist distinct from practice. In this light, the construction of the "dead author"—the keystone to redemptive contextualization for visual studies—succeeds less in privileging the object in the presence of the beholder (as Roland Barthes would have it) than in discrediting practice and reconstituting artistic intention as pure concept, unsullied by materiality.

The problem that arises with such art theories is the problem that arises with all uses of intentionality: It locates the authority of the work of art not in the complexity of responses to it, but in what is presumed to be the character and quality of its source. As such current theories are washed away by the tide of new art that asserts its material presence, art theorists might do well to consider that the most esteemed art historians and

120

critics earn their reputations less for their grand theories than for their quotidian observations—the complexity and quality of their responses to the rhetorical aspects of individual physical objects in the world. In any case, one can hardly deal honestly with undeniably embodied meaning without calling into question the basic premise of the idea of the liberal arts, that antique assumption that the arts of the mind are superior to the arts of practice. At the end of the twentieth century, it is time to come to terms with the reality that art objects earn their value in the social economy, and that one might know all there is to know of "vision," and still know nothing of art.

The essays collected in this book developed out of whim, fancy, and curiosity, but never without the colloquy and encouragement of friends and colleagues.

I owe a special debt to my editor Gary Kornblau, whose intelligence and expertise are felt on every page. He has the most thankless of jobs. His patience and sympathy sustained me at moments of despair. I think of him as family.

I also wish to thank my graduate committee at the University of New Mexico for accepting expanded and annotated versions of five of these essays as my dissertation. The close readings and helpful suggestions of David Craven, Joseph Rothrock, Christopher Mead, and Gus Blaisdell are greatly appreciated. I am also grateful for a grant from the Nevada Arts Council and the National Endowment for the Arts that helped in the acquisition of first-rate illustrations, and to Tracey Shiffman for her lovely, devoted design of this volume.

The earliest conceived of these essays, "New Mexico," originated as an informal talk given to the Philosophy Discussion Group of the Unitarian Church in Los Alamos, in 1989. The warm reception by that small band of curious souls to my first art talk encouraged me more than they know. Special thanks must go to my good friend Dante Stirpe for sharing his expertise in physics and for his generous technical and moral support.

Mary Warner's invitation to give a lecture in conjunction with her audacious 1994 "Showgirl" exhibition at the Contemporary Arts Collective's Temporary Contemporary Gallery in Las Vegas, which was funded by a grant from the Nevada Humanities Committee, provided the occasion for ruminations on that topic.

Many of the ideas incorporated in "The Redemption of Practice" were formulated in an essay on the work of Polly Apfelbaum for the Neue Gesellschaft für bildene Kunst (NGBK) in Berlin, and I must acknowledge the inspiration of the marvelous work of this modern-day Rubenist.

I also must thank those whose own writings have inspired me along the way and who have offered words of encouragement when needed most: Christopher Knight, David Pagel, MaLin Wilson, Frances Colpitt, Peter Schjeldahl, Rebecca Solnit, David A. Greene, Barbara Stafford, Bernard Welt, and the late Grover Lewis.

Catherine Brundage has been more than my assistant at the Bellagio Gallery of Fine Art. She has helped me balance my

time between scholarly and curatorial demands, and generally been a friend. Edmund Pillsbury generously took time to read the manuscript and make helpful suggestions, and Kathleen Clewell kindly proofread a final draft.

I thank Ingrid Calame for allowing a detail of one of her paintings to grace the cover of this book—for making an art that ardently embraces secular contingency, colonizes rather than deconstructs Modernist abstraction, and ratifies feminism by its very existence. I also thank friends James W. Anthony, Karen Carson, Rae Lewis, and Christina McFarland. My father, Otis Otey Lumpkin, inspired my interest in art. My mother, Betty Jo Walters Grace, though mystified by my determination to pursue a course of study that promised little security or reward, never wavered in her support.

I thank the art students too numerous to list who have challenged me to explain my positions and, consequently, to develop a method of studying art, and I thank the Reverend Ethan Acres for his kind benedictions.

Finally, I owe the greatest debt to my husband Dave Hickey, for whom thought and practice are one.

*

"The Smiley Face" was first published as "Not So Enigmatic: A History of the Smile" in *Art issues.* #30 (November/December 1993). "The Prohibition Symbol" was first published as "The Sheriff of Not: A Short History of the Diagonal" in *Art issues.* #34 (September/October 1994). "Chance Art" was first published as "The Cosmic Casino: A History of Chance and Its Denial" in *Art issues.* #40 (November/ December 1995). "New Mexico" was first published as "Writing on the Rocks: A History of the Post-Apocalyptic Landscape as Seen through New Mexico, Art, and the Atomic Bomb" in *Art issues* #37 (March/April 1995). "The Showgirl" was first published as "Supreme Courtship: A History of the Showgirl" in *Art issues.* #33 (May/June 1994). "Feminist Art i: Sexual Politics" was first published as "Unintended (Ph)allacies: A Feminist Reading of 'Sexual Politics'" in *Art issues.* #44 (September/October 1996). "Feminist Art ii: Bad Girls" was first published as "Bad Girls West" in *Art issues.* #32 (March/April 1994). "Feminist Art iii: Virtue Be Damned!" was first published as "Virtue Be Damned! A Modest Proposal for Feminism" in *Art issues.* #42 (March/April 1996). "The Redemption of Practice" was first published as "Dire Consequences: A Short History of Art as a Liberal Art" in *Art issues.* #50 (November/December 1997).

Plates appear on the inserts preceding page 1 and following page 128. The best efforts were made to receive permission for reproduction from the copyright owners of the works listed.

1 Smiley Face Button. Courtesy the Smile Face Museum, Silver Springs, Maryland.

2 Leonardo da Vinci, *Mona Lisa*, ca. 1503-06. Oil on wood, 30¼ x 20⅞ inches. The Louvre, Paris.

3 Frans Hals, *Laughing Cavalier*, 1624. Oil on canvas, 33¼ x 27 inches. The Wallace Collection, London. Reproduced by permission of the Trustees of the Wallace Collection, London.

4 Charles Le Brun, *La Joye* [Joy], ca. 1668. Ink over black chalk on paper, 7½ x 10 inches. Department of Graphic Arts, The Louvre, Paris.

5 Charles Le Brun, *Le Ris* [Laughter], ca. 1668. Ink over black chalk on paper, 7½ x 10 inches. Department of Graphic Arts, The Louvre, Paris.

6 Quentin Massys, *Ill-Matched Lovers*, ca. 1520-25. Oil on panel, 17 x 24¹³⁄₁₆ inches. Alisa Mellon Bruce Fund, Photograph © 1999 Board of Trustees, National Gallery of Art, Washington, D.C.

7 Anonymous (Greece), *Kouros*, ca. 530 B.C.E. or modern forgery. Marble, 80 inches high, The J. Paul Getty Museum, Malibu, California.

8 Indian (Mathura), Kushan period, 1st-3rd century, *Seated Kapardin Buddha with Two Attendants*, 82 C.E. Red sandstone, 36⅝ inches high. Kimbell Art Museum, Fort Worth, Texas. Photograph by Michael Bodycomb.

9 Trinity Shot, Alamagordo, New Mexico, July 16, 1945. Photograph courtesy Los Alamos National Laboratory.

10 Georgia O'Keeffe, *Ram's Head with White Hollyhock-Hills*, 1935. Oil on canvas, 30 x 36 inches. Brooklyn Museum of Art. Bequest of Edith and Milton Lowenthal. Photograph © 1999 Artists Rights Society (ARS), New York/The Georgia O'Keeffe Foundation.

11 South Pueblo, Taos, New Mexico. Photograph by Sarbo®.

12 The Very Large Array, Plains of San Agustin near Socorro, New Mexico, dedicated October 10, 1980. Photograph © 1989 National Radio Astronomy Observatory/Associated Universities, Inc.

13 Walter De Maria, *The Lightning Field*, 1971-77. Courtesy Dia Center for the Arts, New York. Photograph by John Cliett. All reproduction rights reserved.

14 Camel Rock, near Santa Fe, New Mexico. Photograph by Sarbo®.

15 Andy Warhol, *Orange Car Crash*, 1963. Acrylic and silkscreen ink on canvas, 106 x 82 inches. Courtesy Galeria d'Arte Moderna, Turin, Italy. Photograph © 1999 Artists Rights Society (ars), New York/The Andy Warhol Foundation for Visual Arts. Photograph: Alinari/Art Resource, New York.

16 Untitled folio illustration after Albertus Magnus, ca. 1400.

17 André Masson, *Battle of Fishes*, 1927. Sand, gesso, oil, pencil, and charcoal on canvas, 14¼ x 28¾ inches. The Museum of Modern Art, New York. Purchase. Photograph © 1999 Artists Rights Society (ars), New York/adagp, Paris.

18 Jackson Pollock, *Autumn Rhythm (Number 30)*, 1950. Oil on canvas, 105 x 207 inches. George A. Hearn Fund, The Metropolitan Museum of Art, New York. Photograph © 1999 Artists Rights Society (ars), New York/Pollock-Krasner Foundation.

19 Jean Arp, *Collage Arranged According to the Laws of Chance*, 1916-17. Torn and pasted paper, 19⅛ x 13⅝ inches. The Museum of Modern Art, New York. Purchase. Photograph © Museum of Modern Art/1999 Artists Rights Society (ars), New York/vg Bild-Kunst, Bonn.

20 Marcel Duchamp, *Monte Carlo Bond*, 1924 (detail). Photo-collage on colored lithograph, 12¼ x 7¾ inches. Photograph © 1999 Artists Rights Society (ars), New York/adagp, Paris/Estate of Marcel Duchamp.

21 Marcel Duchamp, *Bicycle Wheel (Readymade)*, 1913. Replica of lost original, 25-½ inches in diameter. Philadelphia Museum of Art. Given by the Schwartz Galleria d'Arte. Photograph © 1999 Artists Rights Society (ars), New York/adagp, Paris/Estate of Marcel Duchamp.

22 Anonymous, *The climax of the lover's pilgrimage*, fourteenth century. ms. 137 *(Roman de la Rose)*, folio 146v. Biblioteca de la Universidad, Valencia, Spain.

23 Rogier van der Weyden, *The Lamentation of Christ*, center panel, *Mary Altarpiece (Miraflores Altarpiece)*, ca. 1440-44. Oil on panel, 28 x 16⅞ inches. Preussischer Kulturbesitz Gemäldegalerie, Staatliche Museen zu Berlin. Photograph by Jörg P. Anders.

24 Prohibition Symbols. Courtesy *Print* magazine, New York. Artwork © 1999 *Print*.

25 Edward Ruscha, *Standard Station, Ten Cent Western Being Torn in Half*, 1964. Oil on canvas, 121½ x 65 inches. Courtesy the artist.

26 Barbara Kruger, *Untitled (It's our pleasure to disgust you)*, 1991. Photographic silkscreen on vinyl, 90 x 126 inches. Courtesy Mary Boone Gallery, New York.

27 Peter Paul Rubens, *Elevation of the Cross*, ca. 1610-11. Oil on canvas, 182 x 134 inches. Antwerp Cathedral, Belgium.

28 Jacopo Tintoretto, *The Last Supper*, 1592-94. Oil on canvas, 144 x 216 inches. San Giorgio Maggiore, Venice, Italy.

29 Pieter Brueghel the Elder, *The Peasants' Wedding*, ca. 1568. Oil on wood, 45 x 64 inches. Kunsthistorisches Museum, Vienna.

30 Francisco de Goya, *The Naked Maja*, ca. 1800-03. Oil on canvas, 39 x 76 inches. Prado Museum, Madrid.

31 Theo van Doesburg, View of the cinema and dance hall of the Aubette, Strasbourg, France, 1928 (destroyed). Photograph © 1999 Artists Rights Society (ars), New York/ Beeldrecht, Amsterdam.

32 Inanna-Ishtar, ca. 2000 b.c.e. Terracotta. The Louvre, Paris.

33 Donatello, *David*, ca. 1444-46. Bronze, 62¼ inches high. Museo Nazionale del Bargello, Florence, Italy.

34 "Miss and the Girls" in *Ça c'est Paris*, 1926. Costumes by Gesmar for the Moulin Rouge, Paris.

35 The Dolly Sisters at the Moulin Rouge, Paris, ca. 1925.

36 Las Vegas showgirl (Katherine Saxe), ca. 1969. Photograph courtesy Katherine Saxe.

37 Inanna-Ishtar, *The Burney Relief*, ca. 2000 b.c.e. Terracotta plaque, 19½ x 14½ inches. Photograph courtesy Christie's Images, New York.

38 Hannah Wilke, *Marxism and Art: Beware of Fascist Feminism*, 1974-77. Off-set lithograph on heavy stock paper, 11½ x 9 inches. Photograph courtesy Ronald Feldman Gallery, New York.

39 Lady Bird Johnson among the wildflowers, April 9, 1968. Photograph courtesy of the Lyndon B. Johnson Library Collection, Austin, Texas. Photograph by Robert Kundsen.

Libby Lumpkin
is Curator of the Bellagio Gallery of Fine Art
in Las Vegas, Nevada.
She is an art historian and critic,
and has taught at the
University of Nevada Las Vegas and
the University of California Santa Barbara.
She received an M.A. in art history
from the University of Texas at Austin
and a Ph.D. from the
University of New Mexico.

Photo: Andy Wallace

This edition is designed by Tracey Shiffman with Hillary Sunenshine. It is typeset in Janson with heads in Linoscript and printed on Valorem Text, Precision Book wrapped in Gilclear Oxford, and Sundance Felt Cover by Sinclair Printing Company, Los Angeles.

22

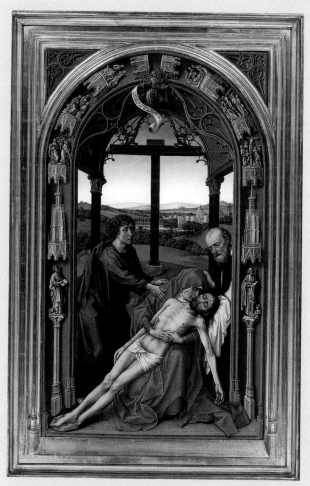

23

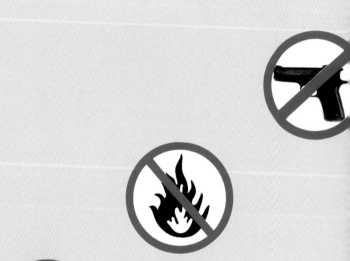

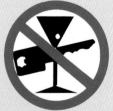

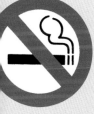

25

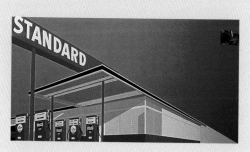

26

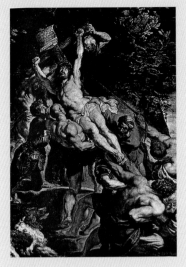

27

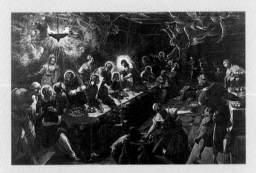

28

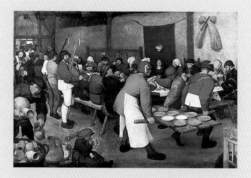

29

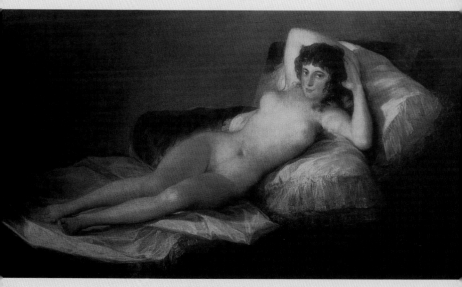

30

31

32

33

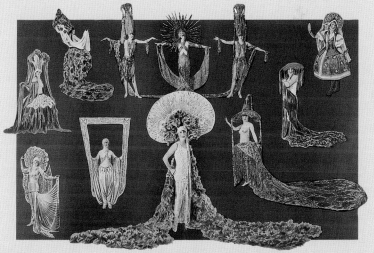

34

35

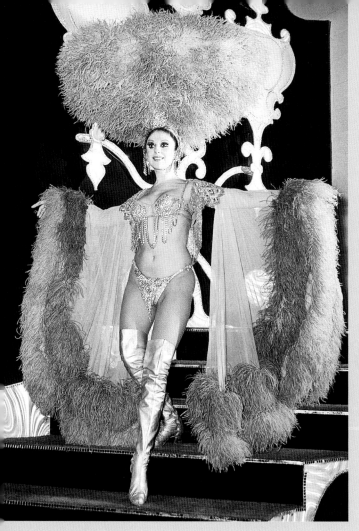

36

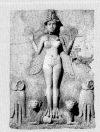

37

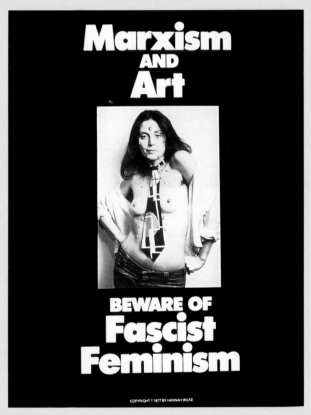